CHANGING TIMES *Series*

Wollaton
remembered

SOUVENIR PROGRAMME

Price 6d.

The Greatest War-Time Show in the Country

(Organised by Mr. JACK SAIL *President*—MIDLAND & DISTRICT PONY RACING ASSOCIATION)

to be held on

WOLLATON PARK • NOTTINGHAM

SATURDAY, July 31st, SUNDAY, Aug. 1st & MONDAY, Aug. 2nd, 1943

AGRICULTURAL • HORTICULTURAL • CATTLE
HORSE SHOW & RACES

PROCEEDS—THE NOTTS. SERVICES AND PRISONERS OF WAR COMFORTS FUND

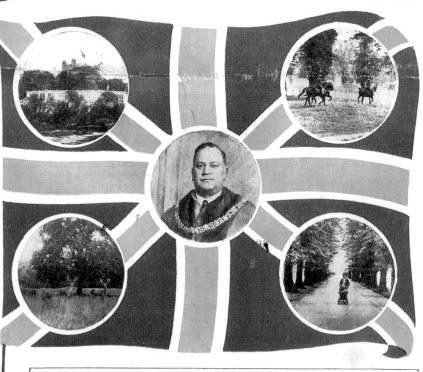

WOLLATON PARK—The BEAUTY SPOT of the MIDLANDS

CHANGING TIMES *Series*

Wollaton
remembered

Compiled by
Keith Taylor

TEMPUS

First published 2002
Copyright © Keith Taylor, 2002

Tempus Publishing Limited
The Mill, Brimscombe Port,
Stroud, Gloucestershire, GL5 2QG

ISBN 0 7524 2270 7

Typesetting and origination by
Tempus Publishing Limited
Printed in Great Britain by
Midway Colour Print, Wiltshire

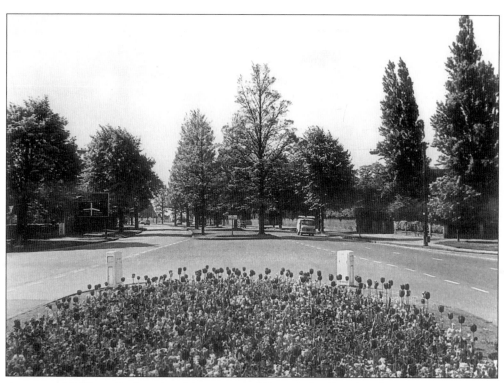

A matured Middleton Boulevard with lime trees and flower beds. (Local Studies Library)

Contents

Introduction and Acknowledgements

The author wishes to acknowledge and express his thanks to Vernon and Shirley Jackson, Freda Parkes, Lionel Baker, John and Yvonne Farnsworth, Bill Ash and Trevor Widdowson, all of whom provided material and shared their time with me while reminiscing about Wollaton in bygone years. Some, like Mary Bell, Wilfred Widdowson, Lawrence Baker, Harold Walton, Cyril Allen, Lou Upton and Ida Page (*née* Hooley), who have unfortunately passed on, enthused either about the Wollaton they knew or their times of employment spent around the park or village.

Having been employed at Wollaton Park myself, I lost no time in exploring the stable block interiors, particularly the flats, corridors and clock room. I also met elderly members of the public who had a tale to tell, and surprisingly there was what might be termed a social history bridge connecting bygone times to the present. Born relatively close by, in Chalfont Drive, I was taken to Wollaton Park and along the canal quite regularly from the age of three and a half.

By the time I was thirteen I was also maintaining a diary (that founded a collection) and exploring Wollaton on most summer evenings and at the weekends. Whenever time allowed, I sought out Wilfred Widdowson, George Glanville and Ted Hardy the patrolmen, Lionel Baker, or Mr Brown the canal lengthman, and the gypsies who were usually camped on the various tracts of derelict land between Coach Road and Raynor's Bridge. Each in his or her own way was a character and made, for me, the meetings colourful and intriguing.

Neither should I forget Ted Eales, the Martin's Pond water bailiff, Bill of Tranby Gardens who used to spend time conversing with Cyril Allen and me outside Lodge Two which was then Cyril's home, and Denis Crewe who showed me around the Head Gardener's cottage, from the tree alongside which we flushed a little owl.

A large proportion of the photographs in this book were taken by the late Frederick William Parkes who was employed as the first superintendent of Wollaton Park. The photographs were kindly donated by his daughter, Freda. Other photographs and postcards were chosen from a selection held by Wilfred Widdowson who was employed at Wollaton Park for fifty-five years. His son, Trevor, contributed one or two taken in more recent times. Photographs of the Middletons, Wollaton Hall's interior and 'grand occasions' belonged to my late uncle, Charles Shaw, who was a professional photographer from around 1912 to 1936.

Past acquaintances gave me verbal permission to use their work here and there and other pictures, where acknowledged, are part of my collection which includes most of the canal studies. Little did I realize that when, as a youth barely out of school, I photographed scenes of this once much-wandered waterway, I was recording monochrome images that would be regarded as historical reference for what was then the future.

Finally, thanks to my friend, naturalist and tree enthusiast Mike Willars, who has recently alerted me to the splendour of many tree and plant species still thriving in the formal gardens of Wollaton Hall and park.

Keith Taylor
Wollaton, April 2001

CHAPTER 1
A Brief History of Four Centuries

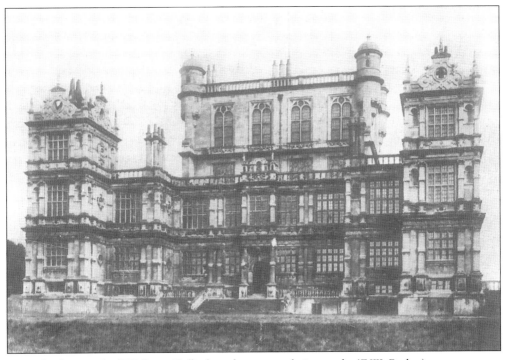

An early photograph of Wollaton Hall's formal entrance, facing north. (F.W. Parkes)

The first Lord of Wollaton was Eustachius de Moreton, followed by Robert de Moreton, who acquired and held for William Peveril the area that we know today as Wollaton and also tracts of Cossall. The commercial forerunner of Wollaton's extensive history, however, was Ralph Bugge, a wealthy trader in wool and woad who acquired an estate at Willoughby-on-the-Wolds around the year 1240. His surname was eventually enhanced

by the grander title of 'Sir Richard de Willoughby'. Ralph's son was also called Richard and it was he who married Isabella, heiress to the fortunes of the de Moreton land-owning family who were still established at Wollaton.

The original Wollaton Hall was built close to the church and rectory. It was surrounded by a relatively small tract of parkland that is best described today as covering the few

compact acres bordered by the Admiral Rodney on one side and St Leonard's Drive on the other. Historians have pointed out that the stone used for this building can be seen in the main structure of the walls on either side of Church Hill which links Wollaton Road with the village.

Scant records of the hall exist giving numbers of staff employed, an inventory of personal and domestic belongings and a list of animals, including oxen and deer which were retained within its pole-fenced boundaries. The deer were probably driven in from the southern edge of the Sherwood Forest country and associated with the hunting grounds of Bestwood, or 'Beskewood' as the area was then known.

It was Francis Willoughby (1546-1596) who chose the site for the Wollaton Hall

The south terrace, Wollaton Hall. (F.W. Parkes)

that we know today. By this time, the coal mined in his manorial pits were creating further wealth. Critics of Willoughby described Wollaton Hall as an expensive luxury and its original designer was disputed long after his death. Cassandra Willoughby, the Duchess of Chandos and a noted diarist, stated in 1702 that the main builder and designer was Robert Smythson, to whom there is a monument in St Leonard's church. The wording *'Robert Smythson, gent, architect, and surveyor unto the most worthy house of Wollaton'* leaves us in little doubt as to his craftsmanship and influence in the building of the Hall for which Ancaster stone was used in exchange for coal mined from the Wollaton pits. Smythson had already worked on Longleat House in Wiltshire and, after leaving Wollaton, designed and supervised the building of Hardwick Hall near Chesterfield.

Wollaton Hall took eight years to build. Begun in 1580, it was completed in 1588, the year of the Spanish Armada. The formal entrance faces north but the residents apparently made much use of the south terrace attached to the salon. Engraved in a couplet on the south-side of the buildings are the words: 'Behold this house of Francis Willoughby, Knight, with rare art built to Willoughby's bequethed. Begun 1580 and finished 1588.'

Besides Sir Francis Willoughby, who died in London and was permanently in debt due to expenses incurred while attempting to furnish such a magnificent house, another notable family member was Sir Hugh Willoughby who in 1554 perished in the Arctic while attempting to discover a north-easterly route between Cathay and India. Then followed Francis Willoughby (1635-1672), the famous naturalist and friend of an early published peer, John Ray.

In 1677 the naturalist's son, another Francis, was created a baronet and his brother Thomas chose to take the title of the heirs of the Middleton estates in Warwickshire following his marriage to the heiress, a descendant of Roger Mortimer. Thus he acquired the title of Baron Middleton of Middleton by Queen Anne in 1711.

Early Gardens and Parklands

The move from the original Wollaton Hall to the nearby hilltop stately home designed by Robert Smythson was gradual. We can imagine valets carrying luggage and carts pulled by oxen making regular trips between the two houses. The original hall, however, was not demolished until well into the seventeenth century, for an alehouse or brewery was maintained until the present-day courtyards were built, clothes were laundered and possibly a bakery was in operation. Some members of staff may have been accommodated there.

In the relatively compact parklands, a herd of wild white park cattle were kept, alongside the small herds of red and fallow deer. These cattle were polled, black nosed and black mottled on the inner ears. The Willoughbys and Middletons, however, needed a documented Royal Consent to enclose deer, whereas for keeping cattle no such permission was needed.

Meanwhile, on the hill plateau to the rear of the 'new' Wollaton Hall, formal gardens were being planned and laid out. These

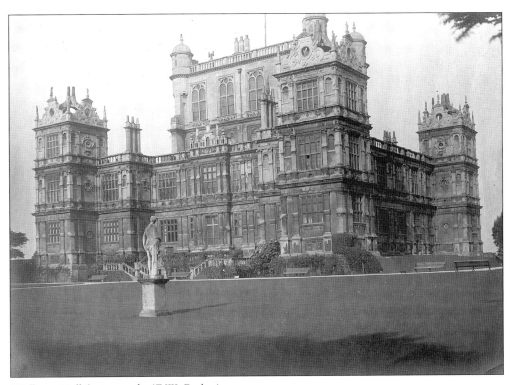

Wollaton Hall facing south. (F.W. Parkes)

9

included an orchard, an orangery connected by three semicircular terraces, fountains and small water gardens improving the view of the lawns as seen from the salon windows.

In an annexe positioned beneath the south terrace, indoor bowls were played, while an outdoor bowling green was maintained within yards of the Hall's east wing. Today a single goldfish pond occupies the central position when seen from the south terrace. Its fountain is operated by adjusting a pump beneath the pond which a workman can reach through a tunnel which extends from the lower garden's tier wall. A late employee and good friend Wilfred (Bill) Widdowson once pointed out to me a wall which had been built to seal up the tunnel here, whereas it originally led to the indoor bowling annexe. What neither of us ever established, however, is whether or not the tunnel was designed when the formal gardens were first laid out.

As featured in other stately home parks, a dry moat or ha-ha surrounded the gardens and the summerhouse facing west by south-west may have originated from those far-off times.

The Dovecote

The dovecote was considered an asset to all English country estates, for the birds gorged on the crops planted by the tenant farmers and ensured a constant supply of fresh meat, summer and winter alike. The tenant farmers were not allowed to harm the pigeons.

The Wollaton dovecote was built by Sir Francis Willoughby around the middle of the sixteenth century. For many years the initials FW were to be seen engraved in the dove-

Church Hill. The stone walling may have been used for the original Hall. (F.W. Parkes)

Wollaton Park, extending east from the formal gardens. (F.W. Parkes)

cote's south wall and the pigeons entered and left by a louvre or opening in the roof. The steward who maintained the accounts in 1679 was probably unaware that he was creating a fragmentary aspect of history when he recorded that he paid '2 shillings for cleaning the pigeon holes'; '4 shillings for obtaining salt cells'; and '14 shillings for corn for the pigeons in winter.'

The Seventeenth Century

Wollaton Hall and its formal gardens were the subject of a painting by Jan Siberechts in 1695, which justifiably is still part of Lord Middleton's collection. Just to glance at a print of it brings to mind the right word – grandeur!

The sixteenth century is synonymous with the tree planting efforts of members of the Middleton family and their employees. By 1666 many landowners, influenced by John Evelyn's publication *Silva*, had planted their formal driveways with lime trees, known also as 'quicksets', for they were fast growers and suitable for a country house environment. Thus at Wollaton, as elsewhere, the locally famous Lime Avenue was established. The second popular vogue in trees occurred later in the century, when groves of sweet chestnut were planted. One such grove can be seen today on Middleton's Paddock.

In 1660 an avenue described as the Great Walk between Wollaton Hall and the marshy tract that later became the lake was 'set with acorns between Michaelmas and Christmas'. Part of this avenue probably still runs directly down from the garden footbridge to the south-west, but these trees are predominantly lime. The Great Walk appar-

ently fringed the marshy tract and its south-east edge, then proceeded through the area that later became Thompson's Wood and terminated at a gateway and lodge built into the wall somewhere in the region of the Abbey Gates section of Derby Road. For some unrecorded reason these oaks were felled, probably at the end of the seventeenth century. They were perhaps requisitioned by the Navy.

The hall's north-facing formal entrance is as good a place as any to point out the groves and avenues of oak, beginning with the two avenues that link the park and courtyards to the lodge gate entrances on Wollaton Road.

Oaks flank these avenues for most of the way and only a matter of yards from then one leading down to Lodge Two another double line of oaks peters out about three-quarters

of the way down the Forty Acre, as that land tract became known. The Lodge Two Avenue has to my knowledge always been referred to by that name, whereas the avenue connecting Lodge One was at some unrecorded time called Albany Avenue.

This avenue joins up with the lower section of the formal entrance route, Lime Avenue, and crosses the top of an avenue that takes the walker directly down from the Hall's east slopes to Wollaton Road. This again is an avenue of oaks but with a few horse and sweet chestnut added and fewer walnut trees. However, the oaks may have been planted in the sixteenth century when the avenue, then unnamed, had open views on either side.

A spinney of fine beech trees screens the Glenn Bott School as one walks down this

The splendid oak on the south-west of Arbour Hill. (J.R. Sutton)

avenue today and oaks are again the predominant trees forming two further spinneys, one around the golf pavilion and the other leading the eye away from the golf maintenance sheds at the top of Lime Avenue. Just below the east slopes and on the golf course stands the Family Plantation, with its oaks and pines planted by members of the Middleton family, as its name implies.

In the shallow and picturesque valley to the south west, Deerbarn Wood nurtures the expected oaks, beech, pine and larch, with a few self-generated silver birch enhancing the scene. Arbour Woods, topping the south slope facing the Hall, is planted with similar trees and likewise is regarded as a deer and wildlife sanctuary.

Lime trees flank the wall along Derby Road down to the formal entrance gates at Hillside, but some splendid beeches also screen the houses now on Adam's Hill. Limes and oak also flank the Wollaton Road walls between the village and Middleton Boulevard.

Harold Walton, who was employed at Wollaton Park for three decades of the twentieth century, kept a notebook in which he listed all the tree species he identified throughout the enclosed park. The overall total came to 135. In my estimation, the most significant tree in Wollaton Park is also the least recognized. It is an oak, singular and of admirable proportions, positioned behind Arbour Woods and overlooking what today is the University campus. In its planter's time, the view would have differed considerably and would have overlooked the Trent flood plain. This oak was surely planted here intentionally in the sixteenth or seventeenth century but by whom we shall never know.

A matter of days after I took Mike Willars, a friend and tree conservationist, to look at the oak, he persuaded me to return so that we could photograph and measure it. So impressive are the branches of this tree that it is difficult to know from what angle to take a photograph. As for its circumference, we had the tape meeting at 24ft.

Wollaton's second impressive tree is the horse chestnut planted in the village beside the entrance to the William Wright Institute sports field. On the opposite side of the road, incidentally, some interesting old trees include a copper beech or two which are still withstanding the winter gales as they tower above and enhance the gardens of the private houses.

The Eighteenth Century

In the late sixteenth and early seventeenth centuries, as I understand it, Cassandra Willoughby was maintaining her diaries. Do they, I wonder, answer the question regarding the demise of the oaks flanking The Great Walk?

Wollaton Park's periphery wall was also being built at this time. Local legend insists that it took seven men seven years to complete the wall which extends for seven miles around the park land. While I cannot refute the first two statements, I doubt if a seven-mile walk could be completed by walking the park's boundaries. If anything, I would have thought the distance closer to five or six miles.

The Middleton brickyards occupied a site closer to Bramcote Hall than Wollaton. Today no such brickyard exists. But until the canal was filled in, the site extended from the canal bank to the eastern boundary of Balloon Wood. The North British Housing Association estate is built on the brickyard site today and the stretch of Grangewood

One of the few remaining photographs depicting the Orangery. (F.W. Parkes)

Road bordering the estate describes the canal route until it swings sharply away from Latimer Drive. The main route to the brick-yards was along the Wollaton-Trowell Road and through what is now The Paddocks of Bramcote Hall. However, when the owners of Bramcote Hall purchased bricks, Moor Road, which climbed the steep ridge of Bramcote Hills, became the route and it is still recognized today as being the oldest commercial road in the parish. When the horses and oxen were hauling cart loads of bricks to Bramcote Hall, bricks which were purchased from Middleton's, extra horses were harnessed from the stables of Moor Farm (now Bramcote Manor) until in later years the route was made easier by blasting a cleft road across the Bramcote Hills' summit with dynamite.

Dates vary as to when the enclosure of Wollaton Park was completed. Certain sources specify the 1720s, while others insist that these records are out by some fifty years. However, John Sleight, who was employed as a park-keeper by the Middletons for fifty-four or so years, remembered a sage of his youth recalling how the deer were herded the short distance from the old park into the new. John Sleight referred to this in 1823 when he was aged seventy-eight. Therefore he agreed that the deer drive took place when the wall was completed, according to the sage, 'about 1720'. Groups of red deer stags certainly appeared in the paintings of the new Wollaton Hall at this time and because the inner park took in some 800 acres, the herds of red and fallow deer were extended considerably.

As the original Hall was demolished in the seventeenth century and its bricks and stones used to strengthen the sides of Church Hill, the Wollaton Hall referred to from now on is the one that we recognize today.

While building was in progress and tons of bricks being carted to the walls, the various entrance gates and adjacent lodges were planned along with the area now situated between Cambridge Drive and Lodge One on Wollaton Road. In this corner of the park, the Kitchen Gardens, complete with segregated hollowed walls, were built along with the Head Gardener's house, a second orangery, a dairy farm and an exceptionally fine barn which, unlike the farmhouse, is standing to this day. Much of this building work extended into the next century. But the 5th Lord Middleton was not to see its completion, for he died in 1797.

Opposite Hillside, where the formal entrance to Wollaton Hall and Park stands today, several small tied cottages were built. To the right of the formal entrance is a

The Head Gardener's Cottage, still a private residence. Notice the tapering tops of the evergreens, a once important feature of these trees. (F.W. Parkes)

snicket which takes the walker or cyclist through a pine spinney and tract of the new Jubilee Campus on the right. This snicket has been in use possibly since the seventeenth century, for the early entrance gates to the park were situated here and not only used by the gate lodge tenants when they went to Lenton or Nottingham but also by Lord Middleton's drovers when they herded cattle along the rough sand track of Derby Road to and from the Nottingham markets. Mention of Hillside is reason enough here to bring the long arm of the Wollaton section of the Nottingham canal into the picture. The canal was constructed here because Lord Middleton, one of the canal company's prime shareholders, insisted that the waterway pass through the eastern side of his estate rather than swing west and progress below the slopes of Bramcote Hills as originally planned.

The Wollaton Canal

The transportation of coal was the reason for three Nottingham businessmen to hold a public meeting at the Guildhall, in a successful bid to gain shareholders' viewpoints and advice in respect of the formation of the Nottingham Canal Company. The meeting was held on 20 October 1790 and hosted by Henry Green, Thomas Oldknow and John Morris, who then discussed the route from Langley Mill to Nottingham with canal surveyor and engineer, William Jessop. On 1 January 1792, the Nottingham Canal Act was granted Royal Assent. While building was under way, it was estimated that the overall sum needed for completion was £50,000. It was agreed that finding such a sum was possible, particularly if a single share was set at £10 and each shareholder was allowed a maximum of ten shares.

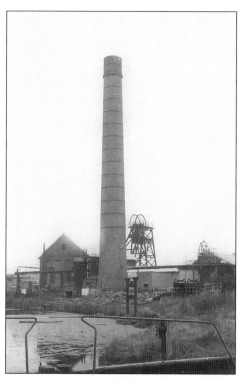

Wollaton Colliery, sited on the canal bank. (From the author's collection)

During the surveying and building of the canal, Lord Middleton pointed out that he wanted the route changed and Jessop and the other shareholders met with this request. After Hillside Derby Road, the canal skirted the wall of Wollaton Park for about half a mile then began its westerly swing which would take it by Lord Middleton's thriving colliery at Wollaton and his brickyard situated a mile or so away. Besides bricks, the site also provided the clay for 'puddlin' or filling in the cracks of the canal bed.

From Radford Woodhouse the canal would undertake a long, steep ascent until it levelled with the Wollaton Colliery. The only way to achieve this ascent was to build sets of lock gates, pounds and sluices. Thus Jessop began pioneering the stretch that became known as the 'Wollaton Flight', a series of staircases and pounds of various shapes segregated by fourteen lock gates, all of which put a further £30,000 on to the original estimate.

However, the route was eventually achieved and the canal proven watertight. It was officially opened in 1796. A pub, the King's Arms, with outbuildings and stabling was built by the canal bridge on the present site occupied by The Roebuck. Meanwhile, in the park, arguments and charges of trespass were breaking out over people claiming that several old rights of way had been enclosed within the park walls, and the stretch of Derby Road cutting through Lenton and bypassing the first gated Wollaton Park entrance at Hillside gained a reputation for harbouring highwaymen, a few of whom were caught and, on at least one occasion, tried and hanged.

The Village Square

The cottages known collectively as Wollaton Square, including those between the Admiral Rodney and the church, were built between 1750 and 1790. Further down Wollaton Road, on the site now occupied by the Willoughby, a square of communal cottages were built and given the name New York Cottages to commemorate his Lordship's visit to that city. The cottages were built back-to-back and provided with a centre yard communal tap. For quite some years, a family named Troope lived there and in fairly recent times I was given a picture of an existence that represented little more than squalor.

Tenant farms with tied cottages, the majority standing to this day, but with some screened by modern houses, were planned

Canal bridge about 1928 at what is now the Crown Island.

and built. Consequently, the Middletons' lawyers were kept busy drawing up land usage and firm boundary agreements in compliance with the Enclosure Act.

Quite a number of occupation-linked cottages extended from the village and along Trowell Road to Balloon crossroads. A sizeable house was also built for the brickyard manager and his family. Several tenant farms extended north into Bilborough and Aspley. Lord Middleton's head steward or land agent lived away from the enclosed park lands in a cottage at the end of Noggins Lane (now Bramcote Lane). A past tenant assures me that the cottage walls are about 18 inches thick. The cottage in those times was overlooked by Bramcote Hills which, even in the 1940s when as a boy I was taken there, resembled the wild Exmoor I was to know in later years. Another steward's house of similar design stands near the corner of Knole Road at the corner of Russell Drive. It overlooked the marshy tract and osier woods that eventually became Martin's Pond and Harrison's Plantation. Lower down Wollaton Road, the tree-lined Old Coach Road provided a wagon way to Bilborough and climbed after leaving the canal bridge.

On the right stands The Lawns, another steward's residence, once rightly named because the gardens were quite splendid. The Lawns stands between Old Coach Road and Woodyard Lane with, in the past, wrought iron gateways and a gravel drive leading off from both thoroughfares. On the opposite side of Woodyard Lane rows of stables opened out on to the road. There was also a carter's repair shed and a farrier's and blacksmith's shop, and again tall trees, probably limes and elms, were much in evidence. Where the lane curved the timber yard was situated and the foreman's cottage, built with windows looking out on to the lane and the private wood opposite. The timber yard entrance was further along on the right and separated from the canal and its bridge by an attractive covert and spinney of larch and Scots pine.

In the private wood (later to become known as Raleigh Wood and opened as a public amenity) a pond described as the Old Fishpond nurtured not only fish but a variety of ornamental ducks and geese which were kept by the family or families occupying The Lawns. The fact that the pond has a central island tells us that in all probability it was man-made and widened and deepened, with the spoil being carted or wheelbarrowed up the lane during the canal-building time and used no doubt for strengthening and maintaining the high embankment.

Martin's Pond

This attractive pond was probably not named as such in the seventeenth century. But I believe that a lake or area of reeds and marsh existed because water continued to cut down and underground from the northern ridge near the Old Park Farm, Bilborough, and possibly from the heights of Strelley. It is possible, although never proven, that the lake was widened and the spoil used for strengthening the canal embankment of the long straight pound which was situated about 500 yards to the north. A central island again suggests that the lake has to some extent been designed according to human whim and need.

The Wollaton Park Courtyards

The stable block and courtyards were built between 1743 and 1774 to a style curiously like that recommended by Robert Smythson,

who not only built country houses like Longleat, Wollaton and Hardwick, but also stable blocks and courtyards. When Smythson built Wollaton Hall, did he also leave plans for a future stable block in the Willoughby vaults? Facing south with the ornate clock, crest and weather vane meeting the eye, the stable block is traditional of those built at the time. Above the arch is a magnificent clock which was probably geared to chime the hours of the day but not the night, with the chimes ceasing around 8 or 9 p.m. The clock was designed and made by Abel Rudhall of Gloucester in 1744. To wind and maintain it, a member of staff had to walk along the back corridors and enter the clock room by a small door. Either side of the entrance the stables contained loose boxes, tack rooms at the far end, a door to the staircase leading to the head groom's residential flat above and a small room that may

have been the quarters of a stable boy. If the groom or coachman was not around when he was needed, he was summoned by a bell installed in the stables below his quarters, which were spacious and connected by a long corridor which ran the width of the block and also allowed access to the clock. The two mounting blocks outside the entrance are still in good repair.

When the stable block was being built George III was on the throne, a fact commemorated by the line of king's heads engraved on the drain-piping of what was then the inner yard. The courtyards and coach houses were built in stages and the laundry, wash rooms, bakery, brewery and dairy added accordingly. These were situated opposite the Ice House Plantation and the steep hill leading up to the Hall's west-facing entrance, and would have been in constant use, with laundry maids and fuel

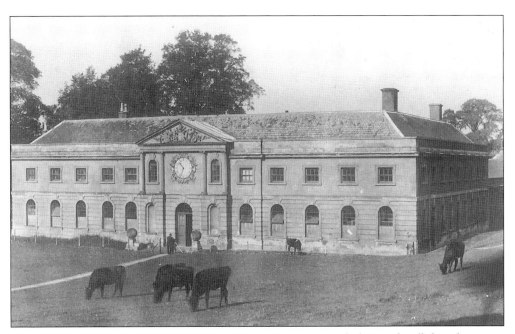

Wollaton Park stable block and courtyards with free-ranging Lincolnshire Red Polled cattle grazing alongside. (F.W. Parkes)

valets in particular carrying and pushing their loads from one building to another. Beyond the second arch and the doorway to the servants' quarters, an indoor riding school was established and the low walled section just to the right of the arch was used as a fuel store and later as kennels for sporting dogs such as setters and pointers. Above the final arch and coach house was the granary and a dovecote opening out above the West wing and stable yards and piggeries.

The Admiral Rodney

Wollaton's picturesque public house, the Admiral Rodney, commemorates the admiral whose naval tactics ensured a victory against the French when, in 1782, a battle was fought in the West Indies during the War of American Independence. The admiral was the stepson of the first duke of Chandos. The duke was then married to Cassandra Willoughby, who was Lord Middleton's sister.

The stonework is considered to be linked with the Middle Ages. Therefore, it would not be unreasonable to suggest that it was part of the original Wollaton Hall.

The Admiral Rodney's banqueting room was at one time used as a school, probably the Russell School, built in the next century.

The Eighteenth Century

In 1803 the gate lodge on Derby Road was pulled down, the wall sealed and a site chosen for a new lodge which appears to have been 200 or 300 yards along. Here, possibly

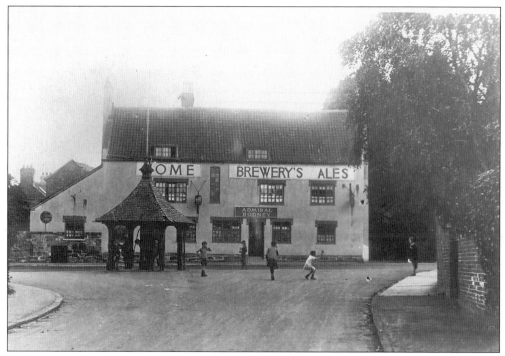

The Admiral Rodney with children playing in Wollaton Square. (F.W. Parkes)

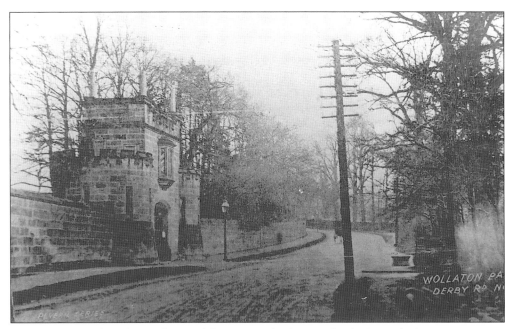

Beeston Lodge and Derby Road, one of the many early photographs. (F.W. Parkes)

opposite Deerbarn Wood, a new lodge was built. Its overseer was the estate bricklayer, Mr Watkinson, who with his team had completed the lodge by 1805.

Local altercations occurred in 1831, for on or around 8 October, the Reform Bill rioters gathered at the gates intent on creating damage and mayhem while celebrating their 'victory', the burning down in Beeston of Lowes Silk Mill. The previous day they had laid siege to Nottingham Castle.

The rioters allegedly 'attacked' the gate lodge and others no doubt scaled the park wall. Once inside the park, however, they re-formed their ranks but were surprised by an opposing force. The Wollaton Yeomanry, led by Colonel Hancox, charged them head on, dispersing the majority but capturing sixteen or seventeen and marching them to the headquarters of the 15th Hussars at Nottingham Barracks, where they were

duly charged. Lord Middleton's steward and land agent in 1815 was John Martin and it was he, I believe, whom the lake known today as Martin's Pond commemorates. The estate's foreman carpenter at that time was William Peet.

In 1820 the estate's head gamekeeper and woodsman set about planting many new oaks and felling the old timbers. Around 1834 the Beeston Lodge that we know today, then called Beeston Tower, was built and the sixth Lord Middleton consented to closing the second lodge and again having the wall bricked up. The new and final lodge was built to house two families and has a spiral staircase and, at that time, had a small garden on either side. The gates were as usual kept locked and anyone needing to enter the park had to ring a bell. Today one can trace a trapdoor beneath the arch. Was this designed so that large items of furniture could be installed? Reference

21

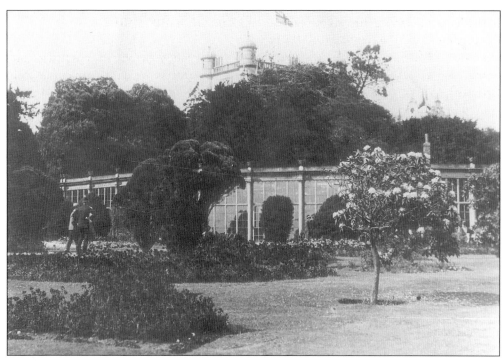

The Camellia House. (F.W. Parkes)

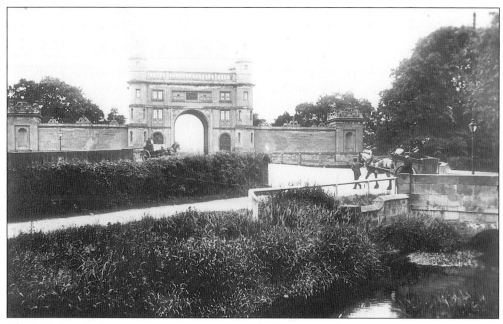

Lenton Lodge, the formal entrance to Wollaton Park. (F.W. Parkes)

to the lodge's tenants dating to the sale of the estate in 1925 can be found in *Priory Demesne to University Campus* by Frank Barnes and is published by Nottingham University Press.

In the meantime, Lord Middleton had thoughts about extending the walled park to the edge of the Wollaton canal and across land on which Ringwood Crescent and Ranelagh Grove now stand. But this was eventually dropped; the reason could have been to do with expenses incurred in employing Sir Jeffrey Wyattville (formerly Wyatt) to work on repairs and re-styling of the ancestral home.

The formal gardens were also being changed and the Camellia House, constructed in 1825, became a unique addition. The style is derived from an iron framework and gratings, coupled with the type of paned glass later used by the designer Paxton at Crystal Palace and Chatsworth House. The overall cost of construction was £10,000, a proportion of which included purchasing and propagating the camellias.

A further £10,000 was spent in building Lenton Lodge, the Elizabethan style gateway, again designed by Sir Jeffrey Wyattville. The year was 1823. Built of limestone, it was from then on recognized as the formal approach to Wollaton Hall, to which Lime Avenue was connected, although the avenue was not entirely straight as the present day avenue suggests but curved slightly to the right. It is likely that the original avenue is hidden beneath the garden soils of the houses on the right-hand side of what is now Wollaton Hall Drive. The 'snicket', mentioned earlier, was maintained as a gateway for the cattle drovers and as a side entrance for the families of the future.

The Sporting Estate

By this time Wollaton Park was living up to its name, for the word park – originally spelt *parke* in Norman French – denoted 'a place where the deer are kept'. Deer parks were maintained by the Normans specifically for hunting.

By the late eighteenth century, wealthy British landowners were adopting another French sport, shooting. The targets were fast and high-flying birds which became collectively known, of course, as game birds. Game laws had been introduced into Parliament by 1671 but the idea of planting small woods or coverts and maintaining rough tracts of land for game preservation really came about with the Enclosure Acts. Maintaining areas of walled park land for the same purpose was highlighted by journalists and correspondents of *The Gentleman's Magazine* first published in the seventeenth century. This was followed by a book *Gamonia: The Art of Preserving Game* by Lawrence Rawstornes and published in 1837.

It was undoubtedly with game preservation in mind that Wollaton Park was re-planned to look very much as we know it today. The marshy tract was enlarged and an inlet strengthened from Martin's Pond, the island was installed in the lake's northern arm and a moat, presumably used for drainage purposes, extended along the east bank which was raised and known as The Duckride. This stretch of bank was closed to everyone except the Middletons and their gamekeepers, for having a 'blind' bank ensured that many species of wild duck found sanctuary there. As a ride described a green route between the trees, this tract of bank was so named because the wild duck gathered to preen and oil their feathers without disturbance.

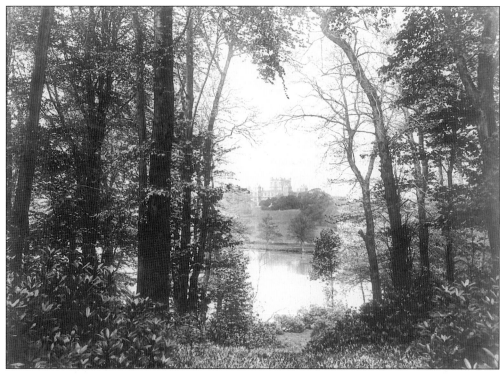

The lake and Wollaton Hall from Thompson's Wood. (Local Studies Library)

The lake is 24 acres in extent and the wide section to the south west is known as The Dam. A boathouse used by the Middletons and their staff was built in the shallows at its south-westerly corner. At around this time the woods were planted and extended around the south and west sides of the lake, connected by a strip screening the boundary wall from what is now Wollaton Vale. The woodland was later extended again in the north-west corner. The name of the woodsman in charge of the planting operations was Thompson which, understandably, is how the name Thompson's Wood that we know today originated. The field separating the two sections of woodland is also known as Thompson's Field. During the planting of these woodlands, it can be assumed that high fencing was erected across the width of the park to prevent the deer and rabbits from feeding on the saplings. Incidentally, the park cattle died in 1835 after eating the poisonous leaves of the yew trees.

Management of the lake and woods included maintenance of the duck decoy which was fed by an outlet, still in existence today. The pipes and ponds of the decoy were dug out and a shooting hut built on the north bank. Here the gentry kept a change of clothes and, undoubtedly, the odd bottle of port and whisky.

A green ride took the decoy man from a gate in the path beside Thompson's Wood to his lodge built into the boundary wall. This lodge is today a private residence and, in any case, Thompson's Wood is not open to the public so please do not use the foregoing as an excuse to explore further!

The need to plant coverts extended across the park to the entrance known today as Digby Avenue, and it was around this time that the avenue was so named to commemorate Digby Willoughby, ninth Lord Middleton from 1877 to 1924.

The open tract of oaks here became connected to a plantation built around the strip of gorse, pine and larch. When all the woods and coverts were later planted with rhododendrons to provide shelter and roost for the pheasants, the wood retained its old name, The Gorsebed. The plantation of Wellingtonia pines at the top of Digby Avenue were probably propagated in the kitchen gardens before being planted on bunter sandstone. A few solitary Wellingtonias were planted elsewhere in the park.

Originally, partridge and woodcock were the main quarry of the sporting gentleman and sometimes his lady, but because they flew faster and higher than partridges, pheasants became the main target. Consequently, many pheasants were reared in the glades of Thompson's Wood and fewer in and around The Gorsebed. The Mongolian, Old English and Chinese ring-necked pheasants were all prized by the Middletons and their staff. But, as mentioned earlier, the pheasants needed shelter or harbour which was why glade after glade of the Wollaton Park woodlands were planted with the recommended thickets of rhododendron. Tenant farmers were also encouraged to maintain coverts and spinneys and, in particular, the tenants of Aspley Hall Farm on the Middletons' northern boundary planted rhododendrons not only throughout the farmhouse gardens but also in the glades of Horseshoe, Shepherd's and Robin's Woods.

Lake scene, featuring the anglers' enclosure and Middleton boathouse. (F.W. Parkes)

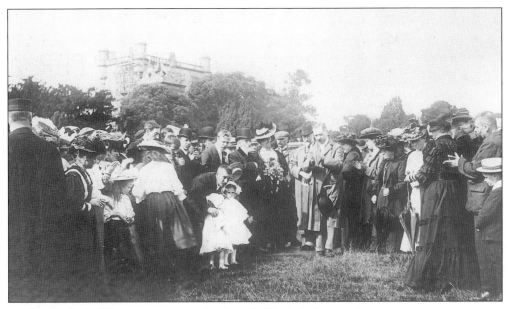

Lord and Lady Middleton opening a garden fête. (F.W. Parkes)

The Late Nineteenth Century

Because of its high ceilings and the costs involved in keeping the rooms satisfactorily heated, Wollaton Hall fell out of favour with the Middletons in around 1878, or perhaps earlier. They had, however, five other residences from which to choose, the favourite having long been Birdsall House in Yorkshire.

They visited Wollaton periodically, particularly during the game shooting season, and presumably rode to hounds. The hound kennels were built on the high rise of land now known as Hirst Avenue, almost overlooking the park. But from which packs the hounds originated or for how long they gave tongue throughout the parish coverts, little, if anything, is known.

The year 1863 was remembered for its gale which uprooted no fewer than 150 trees and 1888, the year in which the Middletons hosted The Royal Agricultural Show. In 1875 Wollaton was connected to Nottingham by a branch of the Midland Railway. Radford station was relatively close to the Lenton Lodge formal entrance but many villagers still preferred to travel by tram, if indeed they could afford the train fare.

To celebrate their twenty-fifth wedding anniversary in 1894, his Lordship and her Ladyship invited all their tenants and families into the park where the Wollaton Colliery Band played in the background, the presents were exhibited in the Camellia House and the general festivities took place in the indoor riding school.

CHAPTER 2
The Nineteenth-Century Village

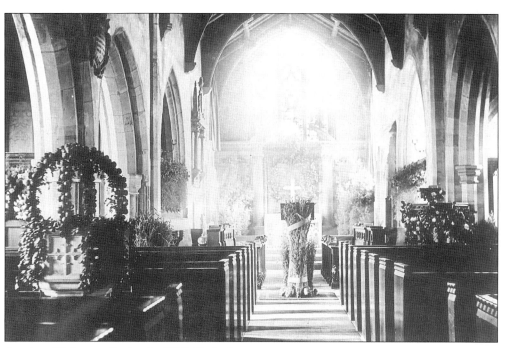

Interior of St Leonard's church. (F.W. Parkes)

St Leonard's Church

The Reverend Russell was always keen for his parishioners to learn something of the history of St Leonard's church, which has a south-facing doorway. Several historians have pointed this out as being a twelfth-century Norman style doorway, but the majority insist that the building we see today originated in the fourteenth century. The original north aisle was replaced around 1500, and the south aisle added when the church was enlarged in 1885.

The open archway beneath the steeple is an interesting arrangement dating back to the Middle Ages, while inside an eye-catching section of panels behind the altar, called a reredos, adds a touch of mystery because, although the church historians have placed this decoration to around 1660, the designer's name has never been recorded, if ever it was known. The Latin Service book, or Antiphonal, dates from the early fifteenth century and was maintained by

William Hussey, Rector of Wollaton from 1448 until his death in 1460.

During the reign of Edward VI and the Reformation, the order was given that all such service books be destroyed. One of the Lord Willoughbys, however, took it into his possession and the book was transferred from the original to the present Wollaton Hall accordingly. Several hundred years later, a member of the Middleton family unlocked a drawer and in 1924 the service book was restored by Lord Middleton to its former home.

The church memorabilia include a brass erected in 1471 of Richard Willoughby and his lady and also an effigy in stone of Henry Willoughby and his four wives; this dates back to 1528. As one would expect, a monument to Robert Smythson 'Architect and Surveyor of Wollaton Hall' holds a prominent position and was erected around 1614. Surrounded by the traditional churchyard yew hedge, several gravestones of Lord Middleton's gamekeepers are still discernible.

There was a keeper named Jacques, a Williamson, and beneath a splendid yew was buried Joseph Archer, who died on 25 November 1812 aged fifty-one years. He may have been the grandfather of Billy Archer, who was the head keeper in Revd Russell's time. Joseph Archer's stone bears the following epitaph:

Death seized upon me unawares,
And took me from my world of cares.
Death is a debt we all must pay,
Consider then thy dying day.

Elsewhere in the churchyard is the grave of William Banner, who for twenty years during the seventeenth century was Lord Middleton's gamekeeper.

During Revd Russell's time, Mr Bland was head of the church bell-ringing team and peals of six bells resounded across the parish fields on Saturday wedding mornings and every Sunday morning and evening. Bell-ringing practices were also held on Tuesday and Thursday evenings.

The Chantry House

Sometimes referred to as 'the stone cottage opposite the church', the Chantry House served, as did all such buildings, as a chapel linked to the church. The purpose was to have a paid priest to say prayers, preach and sing masses for the titled favourites of the parish and their souls.

There is a record of a two-house chantry dating from 1470 and situated close to the original Wollaton Hall. One of these houses served as a home for the priest of each chantry – two in this case – while the other was used as an almshouse for poor people. In this instance, there were three such people who in those times were known collectively as 'bede folk'.

The cottage that we see today is probably the oldest building in the village. Building materials from the original Hall may have been used to strengthen the original foundations. The late Ida Hooley, who lived at the coachman's house next door, gave me the description of a three-bedroomed property with a kitchen, bathroom and two sitting rooms. The back door was said to be the original door and in her day still contained a wooden lock. Below the kitchen a bedrock cave was used as a cellar.

Memories of the Russell School

The Russell School was founded by Revd Francis Hewgill and Lord Middleton around 1845. The village children had previously attended school in the banqueting room of

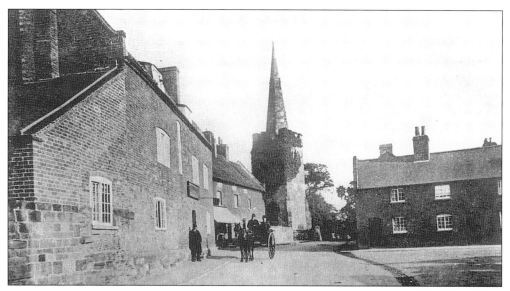

Village scene including pony and trap and the Stores. (F.W. Parkes)

the Admiral Rodney, although between 1472 and 1513 twenty-six boys attended a grammar school, the headmaster of which was Sir William Cowper.

A local newspaper in 1846 printed an article about the Russell School and noted that all the village children attended and were taught the 'three Rs'. In retrospect, it is clear that any boy or girl playing truant would have been quickly spotted in so tight and relatively small a community as early nineteenth-century Wollaton. The pupils who walked the farthest were, no doubt, the Baker children of Cherry Orchard which bordered Aspley Hall. Their route after crossing several fields was along a cart track known as Dobs No Lane, somewhere in the region of the present-day Freemount Drive. They then walked along Woodyard Lane to Wollaton Road but turned right and along by Lodges One and Two, with just the rooftops to be seen behind locked gates, before walking up Church Hill to the village square where they turned left into Noggins Lane.

While he and I were in conversation, Lionel Baker stressed the point that the school was modelled on the teachings of the church with the basic lessons being reading, writing, spelling, arithmetic and Scripture. He recalls walking along Wollaton Road with his brothers and sisters and in March or April clattering a stick against the park wall to put the rooks up from their nests in the oaks and elms towering above Lanes Lodge (Lodge gate Two). Not infrequently, Lionel and his brothers also rang the gate bell, then ran towards the bend at the foot of Church Hill, especially if black-bearded Jack Lane appeared at the gate frowning with irritation and taking several long strides beside the wall to put the children on their way.

The schoolmaster was Mr Jordan and my correspondent says of him:

' "Gaffer" Jordan, as we used to call him, was in all respects the right type of teacher for the right type of school. Quite apart from necessary qualifications or ability, he taught a great deal from sheer example. He

29

Wollaton Road and the park boundary wall as the Baker children knew it on their way to school. (F.W. Parkes)

was always well turned out – immaculate in fact. He seemed to encourage on the right lines or to punish and demean in the right places, and had a fair idea of every pupil's background, talents and ambitions, and drew upon them accordingly.

Cricket for the boys was compulsory, the cricket field being situated a field away from the back of the school. Football was played on a cinder surface in the school playground. It was a difficult pitch, made all the more so by the roots of a tree situated in the middle of the playground.

In the field directly behind the school stood the Dovecote and nearby a flourishing walnut tree which offered a sizeable crop in the season. In the schoolroom to the left of the fireplace was a large glass case containing a selection of locally stuffed birds. Of particular interest was a three-legged sparrow and a pair of nightingales from the nearby coverts.

At least one morning a week just after the church clock had chimed nine, Revd Russell would walk through the doorway and bid "Gaffer" Jordan good morning. We would all stand then and say our good morning to The Reverend, who would lean on his walking stick and then pick a boy or girl from the group and take them aside to talk very briefly about the Bible, and help them recognize one or two of the birds in the glass case. Nor was the history of Wollaton Hall ignored and even when we were quite young we were told that at the time of the Spanish Armada the Hall carried a total of 365 windows and 52 doors.

When the final school bell chimed around 4.30 in the afternoon, we would tumble out of the classroom and rush homewards after perhaps first calling at the Stores for a bottle of lemonade, liquorice stick or sherbet dip.'

Christmas was the time when Sheila and Marjorie Russell assigned Miss Gilbert, the head housekeeper at Wollaton Hall, to help organize the children's carol services both in the church and schoolroom. There was also a special tea laid on and a concert, often with Sheila singing and Marjorie playing the piano. The classrooms and corridors were hung with coloured streamers and tinsel, while the usually bare walls were covered with paintings of snow scenes, robins and Santa Claus. These of course were created by the children, and even the classroom windows were pebble-dashed with blobs of cotton wool to create an atmosphere of snow outside and warmth within. Wilfred Widdowson recalls the Christmas tree, usually a conifer cut down from the Middletons' tree nursery, which was situated near Aspley Hall Farm.

On the day of the concert and carol service the parents were invited into the school hall and each of the thirty or forty children were given a wrapped present. At the begin-

ning of the afternoon, however, all such wrapped gifts were heaped colourfully around the Christmas tree and the candles lit while everyone, children and adults alike, sang carols.

Meanwhile, in the corridor by the school-room door stood the school caretaker with a bucket of water at his heels as a precaution against the candle flames or melting wax starting a fire. Beside his bucket he propped a stick with a sponge tied to its end and with this the caretaker intended to douse any fragment of burning twig or cluster of pine needles.

Many of the children were inside their parents' cottages within a few minutes of leaving school. But for the Baker children that comparatively long walk had to be taken across to Cherry Orchard and often without a light in sight once they had left the canal bridge on Woodyard Lane. Freda Parkes, the head gardener's daughter from Wollaton Park, walked the short distance home at dinner time. For the Bakers, however, the distance would have proven too far, but she told me:

'About half past eleven, no matter what we were being taught, we couldn't ignore the lovely smell of jacket potatoes filtering down the corridors and into the classrooms. These were potatoes that each of the Baker children brought and Mr Jordan's assistant used to put them in the oven for them every day.'

When I reminded Lionel of this, he smiled then related how most mornings he and his brothers would take knives out with them and inch the potatoes from the soil of the several fields they passed through. After cutting off the top of a potato, they would stick it back into the soil and circle it with the knife so that they didn't waste time at that spot the following morning. And his smile widened when he remembered how hurrying home on those dark winter nights, the Woodyard Lane blacksmith would welcome them to his forge and allow them to warm their hands over the fire before the children set off again for home.

The Stores

As one approached the village from the direction of Church Hill, the single village shop became discernible by the fact that a grey shutter was pulled down daily over the window and pavement to provide shade in the summer and shelter from the rain or snow during the winter, for the shop was so small that only two or three people could be admitted at one time. The shop was situated in the row of cottages between the Admiral Rodney and St Leonard's church.

Everyone with whom I have spoken remembers The Stores, which were owned and managed by the Co-operative Wholesale Society, and all agreed that 'almost everything' could be purchased or ordered there. Because fruit, vegetables and meat were relatively easy to obtain and often home-grown, the shop concentrated more on dry goods. Dolly tubs, ponches, wash powder, squares of Dolly Blue, and sink and dish cloths were on sale. Clothes brushes, yard brushes, besoms, fireside tongs, dusters, tins of polish, firelighters, matches, scouring powder and doormats were either displayed or stored 'in the back'. One villager remembers:

'A large delivery van used to call once a week to bring a consignment from the wholesalers, but I used to think there were enough scrubbing brushes and boxes of wash powder to last the village for the next hundred years.'

The shop was largely visited by women and children, although workmen would drop by for their weekly supplies of thick twist tobacco or thirty or forty cigarettes and several boxes of matches. The children

bought ice-creams, bottles of lemonade and sherbet dips. About two weeks before the Goose Fair opened in Nottingham, they were sold such seasonal fare as an apple on a stick coated with toffee or, at Christmas, a little pink or white sugar-coated pig supplied by the confectioners.

On Saturday evenings the shop was particularly busy because it closed on Sundays and the children were told tersely to get what they wanted that evening because on a Sunday the Stores' front door was closed and bolted, and further that only the doors of the church were unbolted and opened on a Sunday.

The Police House

In the same block of cottages as the Stores, a blue lamp shone at night to indicate the whereabouts of The Police House.

The village constable, helmeted, with truncheon and riding a sit-up-and-beg bicycle, had a beat extending from Lenton Lodge to Balloon crossroads. He was mostly involved with the Wollaton Park game poaching affrays and often met game-keeper Billy Archer and coachman George Parnill in the Admiral Rodney's taproom for a pint. Quite often he would relate how hearing the foxes or barn owls skirling across Trowell Manor was enough to make him turn and pedal for the relative comforts of the sleeping village. Sometimes he met and cajoled gangs of colliers walking to work across the fields or along the canal towpath.

For many years after this cottage became a private residence, the word 'Police' could still be discerned stretching across the front door no matter how many coats of paint were applied with the hope of removing it.

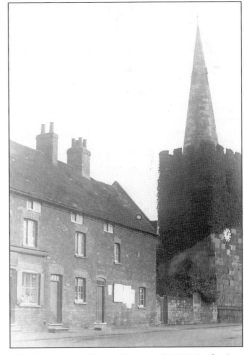

The Stores and Police House. (F.W. Parkes)

The Mortuary

When the Middletons' hound kennels were abandoned and the pack perhaps transferred elsewhere, the buildings on what is now Hirst Avenue were used as a mortuary where the body of an occasional suicide was laid out or identified. The commonest cause of death requiring further investigation hereabouts seems to have been drowning in Martin's Pond or Wollaton Park lake. Lord Middleton's duck decoy man, Harold Pyke, hanged himself from the beams of his tied cottage and Freda Parkes remembers two young girls taking poison and dying side by side on Old Coach Road after receiving the news that a local boy they both claimed to love had been killed in the First World War.

CHAPTER 3
People from the Past

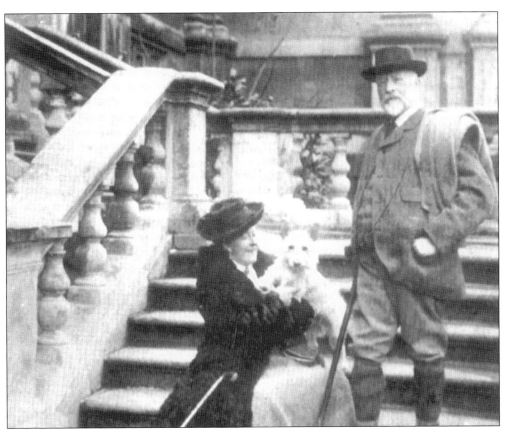

Lord and Lady Middleton with Kyle. (C. Shaw)

The Middletons Remembered

Around 1904, when she was five or six, my mother was one of the many poor children taken on afternoon charabanc trips to Wollaton Hall. Such trips were financed by the local businessmen's charity known as Pearson's Fresh Air Fund. Accompanied by the fund's voluntary guardians, the children were led in twos through the gates of Lenton lodge on Derby Road and past the smiling lodge-keeper families and the first free-range hens most of

them had set their eyes upon. My mother was awed by the grandeur of Lime Avenue with its regimental trees, masses of foliage and the surrounding silence. As they came within sight of Wollaton Hall, a lady dressed in black, wearing a wide brimmed hat and riding side-saddle on a thoroughbred white horse, appeared at the top of the hill and, putting the horse into a canter, rode down to meet them.

The children were told she was Her Ladyship, Lady Middleton. After greeting them all, Lady Middleton led the way up to the formal gardens and here she was joined by her husband. The children were then split into groups each accompanied by a guardian and with His Lordship and Her Ladyship walking from one group to another they played hunt the slipper and were encouraged to use the swings suspended from the Cedars of Lebanon. His Lordship carried tins of wrapped sweets around and showered sweets into the shrubberies for the children to find. Then as a group they danced holding hands, were taken to look at the goldfish pond and strutting peacocks. Around four o'clock they were served tea from a line of trestle tables put up in the courtyards, then they were filed back to the charabancs for half past five.

A White Mule?

One elderly village resident remembered Lady Middleton's fondness for a white mule which she rode accompanied by her husband riding a black Arab stallion. 'They looked an odd couple riding like that,' smiled my informant.

Visiting the Lodge

Both the Head Gardener's daughter, Freda Parkes, and the kitchen maid, Mary Bell, remembered visiting the wives of Billy Archer, the gamekeeper, and Jack Lane, the estate worker, on Wednesday afternoons.

At both of these gate lodge houses they were served tea and seedcake, 'usually with a caged canary singing in the background', and if the Middletons were in residence Her Ladyship would visit as well.

'She was a very sharp, bright lady, but not one to see you sitting by the hearth, sipping tea and talking. Inevitably, she would manoeuvre whatever womanly subject we were discussing around to posture, then make us stand and walk with a pile of books balanced on our heads. "I'm teaching you how to walk properly, *deportment*," Her Ladyship used to stress and – my goodness – she wasn't satisfied until you were walking as gracefully and straight backed as she,' chuckled Mary.

Cottage Visits

Quite often, so I'm told, Lady Middleton rode up to the village and called at the cottages in Wollaton Square. One previous tenant confirms this:

'In those days the doors were never locked but Her Ladyship never knocked or tapped, she just walked straight in. While enquiring of your welfare, she also looked through your kitchen cupboards and in the larder. Oh, she would smile and ask if you had enough food in, but my husband, who was mostly out working in the park, used to reckon she was also checking if we had any fruits out of the kitchen gardens or pheasants out of the park. I respected the fact that the Middletons owned the very cottage we lived in but as for looking into your cupboards, I don't care who they were, they wouldn't get away with it today!'

Absent from the Congregation

Another past tenant of Wollaton Square related how if you missed a Sunday morning service at St Leonard's and the Middletons were in residence, Her Ladyship would again walk into the cottage and enquire if you were sick then ask if you had seen the doctor and what he or she had prescribed as treatment or medicine. Mary Bell on agreeing with this smiled, while adding:

'I remember some Sunday mornings it would be teeming with rain or blowing a blizzard and the head housekeeper, Miss Gilbert, might have appeared hesitant about one or two of us walking from the Hall to the church. But then Her Ladyship would intervene and adamantly state, "You have all been issued with umbrellas and you will all attend the morning service." And that was that. You just had to go.'

Of Scottish Ancestry

From the late Ida Page (née Hooley), I learned that 'Lady Middleton rode across the park to look at the deer whenever she could. She loved to sit in the saddle while a head of forty or fifty wary stags mingled together and sometimes she discussed with my employers, the Russell sisters, the possibility of introducing new blood to the herd. Her Ladyship came from a titled family who owned several deer forest sporting estates in Scotland and I seem to vaguely recall several hinds being transported to Nottingham by rail.'

Presumably, the hinds would then have been transported to Wollaton by horse-drawn cattle truck. I doubt though that a Herd Book record exists relating to this introduction.

Attending a Church Service

The only men who could get away with not attending a Sunday church service were the gamekeepers and woodsmen who always had the stock to check as well as patrolling the park's woods and coverts. Members of their families were expected to attend. One parishioner, well into her eighties, recalled:

'When Lord and Lady Middleton were in residence at the Hall, they were conveyed to the church in a coach drawn by four fine bay horses. Both the coachman and footman rode in attendance. It was a handsome coach, as I remember it, with a livery of deep yellow edged with black. When His Lordship and Her Ladyship were helped from the conveyance a succession of bowing and curtseying took place before they entered the doorway of the House of God, as Revd Russell preferred St Leonard's to be known. After a short walk to their respective pews, the Middletons' members of staff remained standing until their employers indicated they should sit. The Middletons preferred to sit at the back of the congregation and chose the pews on the right-hand side of the aisle. The rest of us agreed at times that we felt as if we were being overlooked.

Following the morning service, all the staff were allowed a short break so that they could visit friends living in the cottages, farms and park lodge gates. Miss Gilbert and her dining and kitchen staff were expected to be out only for a short while though, because they had to get back to the Hall kitchens to prepare the Sunday lunch which was usually served around one o'clock.'

The Reverend Russell

Henry Charles Russell was born at Woburn, Bedfordshire, in 1842. He was the son of Lord

Charles Russell and grandson of the sixth Duke of Bedford. After he was ordained in 1866, he became the Vicar of Wentworth in Yorkshire and married Leila Mary Willoughby, the sister of Lord Middleton.

In his early years, Henry Charles Russell played a leading role in the social affairs of Wentworth and worked closely with the parishioners when the family moved to Wollaton in 1874. Living at the Old Rectory, which was set back from the church and overlooked the fields surrounding Martin's Pond, the Russell family soon made themselves known to both the villagers and the tenants and employees of the Wollaton Hall estate.

It was at The Old Rectory that the couple's second son, Thomas, was born in 1880.

Like his brothers and sisters, Thomas attended the village school on Noggins (Bramcote) Lane, but gained fame in adulthood when he attained the position of Head of the Narcotics Squad with the Cairo police. Known in Egypt as 'Russell Pasha', he won further acclaim by being instrumental in disbanding several gangs of narcotics smugglers.

Serving on several committees revolving around both public and parish affairs, Henry Russell subsidized the village library which was founded in 1857. In 1894 he became the first chairman of Wollaton Parish Council. Along with his daughters, Sheila and Marjorie, he ran the Sunday school held of course in St Leonard's church, and visited the village school at least twice a week to talk to the staff and the children. He left only

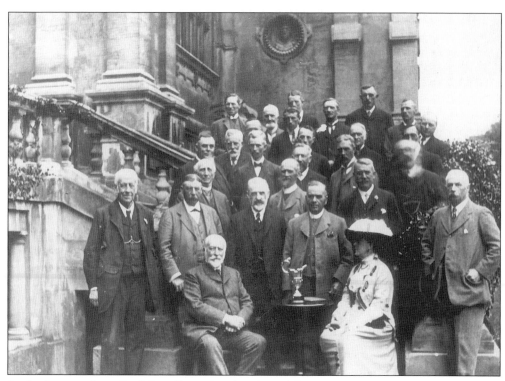

In the foreground are Revd Russell, Lord and Lady Middleton and to the right is the steward, Mr Pilkington. (F.W. Parkes)

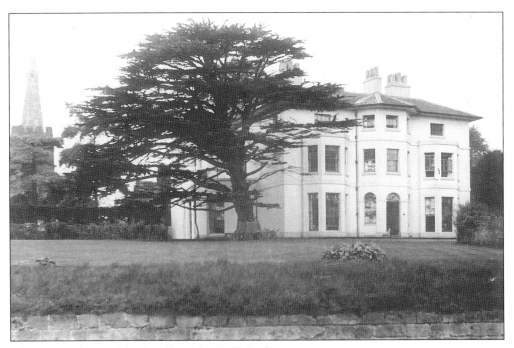

The Rectory, home of the Russell family. (F.W. Parkes)

when he was satisfied that all was well from everyone's viewpoint. But his influence also extended farther afield than Wollaton, for he served on the Children's and General Hospital Committees, became a member of Nottinghamshire County Council and was secretary of the local RSPCA. In 1889 the Reverend arranged for fifty Nottingham coal cart boys to attend a special tea laid on at the Admiral Rodney, and he was always keen to check whether or not the poor had been invited to the annual Rectory Fête. To many parishioners he was the traditional sporting parson and rode to hounds with the South Notts Hunt. He was also a keen angler and game shot. Gardening and bird-watching were two further interests.

The Russells' eldest son was killed in the First World War and those who knew the family during the 1920s saw little of Henry's wife because, besides being in poor health,

she suffered from an ulcerated leg that needed regular attention.

The domestic staff at the Rectory numbered four maids of various status and duties, a cook, gardener and groom. The groom, Mr Hooley, lived in the cottage facing the church gates and next door to the Stone Cottage or Chantry House. The Hooleys' cottage had a kitchen, dining room and pantry, with a small bathroom and three bedrooms above.

At the Rectory, the Revd Henry Russell kept several horses for riding and a team for pulling the state coach which bore the liveries of both the Middleton and Russell families. He frequently asked his groom to accompany him when he intended to ride the lanes around Wollaton, Strelley, Kimberley and Nuthall, and also ensured that when the family were attending a formal function at Wollaton Hall his daughters

As girls, Sheila and Marjorie Russell played in Wollaton Hall's formal gardens and summer house. (F.W. Parkes)

rode inside the liveried coach, much to their excitement.

At the Rectory he employed Miss Millie Sewell who lived in as housekeeper and cook. Being fond of cats, Millie was allowed to keep one or two about the Rectory, but the Reverend's main passion was dogs. His favourite working terrier bitch was called Iona and she competed with Fags, a Labrador retriever, for his affections. A smooth-haired fox terrier, Solomon, used regularly to be chained to the top of the staircase leading down to the Rectory kitchen.

In the Rectory stables two or three black Labradors were housed and occasionally accompanied the Reverend and his family down the fields to their private boathouse beside Martin's Pond. On the few occasions that the dogs began fighting among them-selves, Henry Russell and his sons dragged them by their tails into the shallows and then immersed them in the water, reasoning that the shock would force them apart. When the family rowed out to the island in Martin's Pond, they sat with one dog between each child. One Labrador loved to stand in the bows of the boat between Sheila and Marjorie who sat with their arms around his neck, at least until the oars were lightly dipped into the shallows and the children disembarked, carrying with them a cutlery basket, picnic hamper and several starch white tablecloths.

Such family gatherings obviously dis-turbed the moorhens and coots from the reeds, but the Russells were discreet in all matters concerning the natural world. Any youth or group of off-duty colliers seen

around the banks of Martin's Pond were regarded as trespassers by Revd Russell, who would blow a whistle to catch their attention, then back thumb over his shoulder towards Wollaton Road. If the youths chose to ignore him, The Reverend lost no time in sending his black Labradors in their direction and, as he had always anticipated, this had the desired effect in turning the youths in another direction. It was once strongly rumoured that the Reverend had sought out and boxed the ears of a youth who had been bragging about shooting a barn owl.

Several times a week, Revd Russell strode into the schoolhouse and, after exchanging pleasantries with Mr Jordan, the schoolmaster, singled out one or two boys and girls. He then took the children to a case of stuffed birds and asked them to name each one.

According to one correspondent, 'He performed this exercise in a very gentle manner and corrected us if we were wrong. And sometimes if one of the lads happened to have been looking a bit unkempt, perhaps after a scuffle in the school playground with his classmates, the Reverend would tell him to get cleaned up and then check on his appearance a day or so later.' Meanwhile, each evening in the Rectory drawing room, the Russell children were given private piano and singing lessons, in addition to their school homework.

Every autumn Revd Russell was invited to attend the pheasant shoots which were held on Lord Middleton's estates at Wollaton and Aspley; Squire Edge's estate at Strelley; and Jesse Boot's (Lord Trent's) estate, called Highfields, between Derby

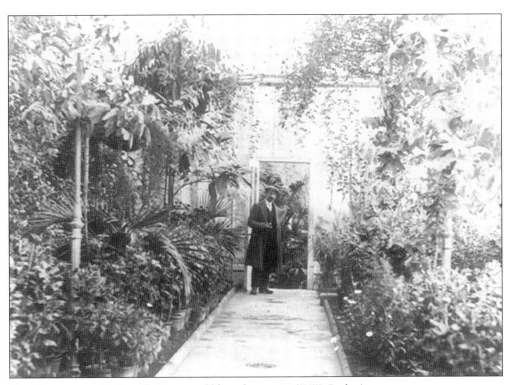

The Orangery as the Russell sisters would have known it. (F.W. Parkes)

Road and Beeston. He also took sporting guests to the small duck decoy that was for a time established in Raleigh Wood. The Reverend never once lost his interest in birds and maintained a quite substantial library in his Rectory study. One ornithological work he gave to a friend whose son has it in his possession to this day. On the inside cover the Reverend had written 'H.C. Russell. Wollaton. 1902' in a neat yet masculine hand.

For close on fifty years, Revd Russell greatly influenced the structure and welfare of the Wollaton village community. Nor were the children forgotten. Every May Day children of all ages were invited into the Rectory grounds to dance around the traditional May pole. In addition, there was an annual 'games day', organized possibly by the Reverend's daughters, and this too was held beyond the cedar lawns but within sight of the Rectory windows.

Other annual highlights were a trip on a longboat from the canal bridge on Trowell Road to Langley Mill, the Christmas party held in the village school hall with presents given to every child in the village, and the Rectory Fête and Gala. This event was held for the benefit of all parishioners and their children. On a lawn between stalls decorated with flags and bunting were held three-legged and sack races, egg and spoon races and pitching the horseshoe competitions. Cakes and bottles of lemonade were sold at the stalls and the profits from these events were ploughed into the Reverend's fund to help the poor. The Fête and Gala Day was rounded off with a rousing finale given by the Stanton and Staveley Works Brass Band.

The Reverend's wife, Leila, died while the family were still together at the Rectory. Presumably, two of the Reverend's four daughters married and moved away from Wollaton, for beyond the fact that they were sisters to Sheila and Marjorie, we know very little about them.

The Russell Sisters

After their father's death, Sheila and Marjorie Russell discovered that there had been no provision made for them in respect of future accommodation. Consequently, their solicitor conferred with the stewards of the Wollaton Hall estate and they were given a sizeable flat above the stables in the Wollaton Park courtyards.

This spacious accommodation had previously housed the succession of grooms and coachmen employed by the Middletons. The flat occupied by the Russell sisters was in the wing of the courtyard buildings to the left of the clock as one takes the paved path down from the ornamental gardens. The flat was entered by way of the porch doorway which today is an entrance to the Industrial Museum. There was also a side door which led out into the deserted saddlery and stables. Their kitchen was situated above the saddlery, the sitting room and bedrooms above the stables. Their furniture was rather plain but according to one correspondent, 'old and valuable'. Some was of the Hepplewhite type, being white-coloured with a cane base.

The living room and bedrooms were spacious and could be entered by way of the red carpeted corridor that extended the entire width of the courtyard buildings. Framed watercolour prints were displayed on the walls and potted plants and palms placed in sizeable vases along the window sills and tops of the sideboard. The beds used by Sheila and Marjorie were four posters, screened by velvet curtains. Drape curtains, plush carpets and tapestries filled the rooms.

Each day the sisters walked up the steep hill path beside the dovecote and entered the Hall by way of the servants' door. Inside the Servants' Hall they no doubt exchanged pleasantries with the Middletons' housekeeper, Miss Gilbert, while a maid prepared them each a hip bath.

Throughout the autumn and winter, Mr Parkinson, the usher who lived in the flat adjacent to the Russells, kept them supplied with kindling, coal and coke, while Millie Sewell cooked their meals and a lady from the village came to dust the furniture and clean the kitchen and bathroom.

Throughout their summers spent in the courtyard flat, the Russell sisters frequently took a boat and rowed across to the island on the lake, observing the water birds, trees and flowers both around the lake and in the woods. Marjorie in particular furnished the *British Birds* magazine with much information about the nightingales which bred in Thompson's and Gorsebed Woods. From 1911 onwards, this magazine included a nightingale survey and Marjorie wrote that these birds were indeed 'denizens of the Wollaton Park woods and coverts'.

Each autumn the two ladies continued to visit the stands of oak where the red deer hinds and calves fed upon acorns and here they would see a breeding stag roaring and chafing, a sight which was enough for them to pause and make notes or sketches on the behaviour patterns of these interesting animals.

In June they walked the slopes of the deer park and counted the number of newly born calves following the hinds. One hot afternoon, the sisters went to buy fresh eggs and vegetables from a farm on Beeston Lane (now within the University campus). Their route took them across the lower slopes of Arbour Hill and around by Deerbarn Wood, which was one of the favoured calving areas used by the hinds.

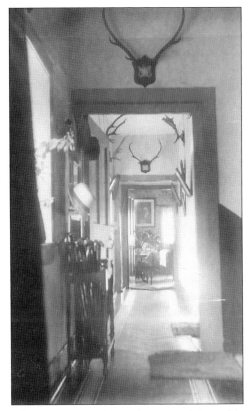

The interior corridor and rooms of the stable block flats. At the time this photograph was taken, the flats were the home of the Parkes family but they had previously been lived in by the Russell sisters. (F.W. Parkes)

As they walked, the sisters became aware of a hind silhouetted, watching them beneath the trees and being obviously protective of her calf that was lying out among the bracken fronds. The hind left the wood and trotted out with the intention of turning the ladies aside. She apparently charged at close range while attempting to butt them at the same time. Understandably, the two sisters were glad when the turreted entrance of Beeston Lodge came into sight. But the protective hind continued her assault until they were about a hundred yards from the building. On reaching

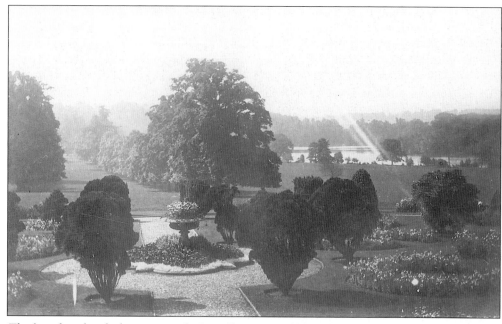

The formal gardens looking west as the Russell sisters would have known them. (F.W. Parkes)

the lodge, the sisters no doubt mentioned the fact to the lodge keeper's wife that caution should be exercised, while at the same time informing her of the time they expected to be re-entering the park.

After purchasing the fruit, fresh vegetables and eggs, the sisters retraced their steps to Beeston Lodge and when they had been re-admitted, decided to give Deerbarns Wood a wide berth and walk instead along the main drive that takes the walker or stroller towards the lake. But within minutes they discovered the hind trotting behind them until aggression induced her to begin butting both sisters in the small of the back! Their attempts to turn the animal aside provided only temporary relief and by the time they had reached the corner where the drive converges with the Lime Avenue leading up to the Hall, their wicker baskets containing the fruit and vegetables were awash with the yolks and whites of a dozen or so smashed eggs. Despite

this hind's obvious aggression, however, neither Sheila or Marjorie lost interest in the deer, nor any animal or bird for that matter.

At their courtyard flat, the sisters kept a number of dogs. My correspondent remembers in particular Toby, a Pekinese; Patch, a wire-haired terrier; Billy, a Blenheim terrier; and a little mongrel bitch called Briar, a stray found exhausted in snow beside a briar patch.

Although they obviously enjoyed living in the courtyard flat, the Russell sisters still taught at Sunday school and helped their father's successor, Revd Thornton, with such tasks as organising the annual Rectory fête and also a succession of dancing sessions which were held once a week on winter evenings in the village hall. They also invited their close friends to the occasional musical evening which was centred around the main living room of the courtyard flat, for Sheila was a trained singer and Marjorie an accomplished pianist.

Sheila and Marjorie Russell with members of the Ladies' Circle. Sheila is kneeling with the dog in front; Marjorie is on her left. (F.W. Parkes)

A fountain at Wollaton Hall. (C. Shaw)

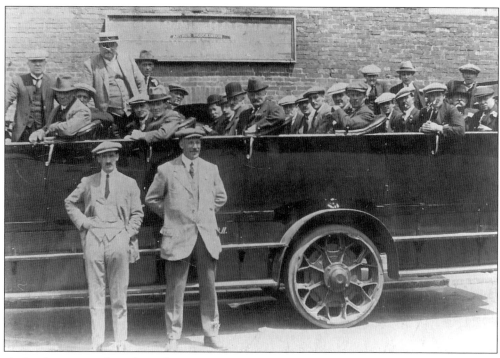

A charabanc outing from the William Wright Institute, 1922-23. (F.W. Parkes)

If they learned that a member of the village community was ill, both ladies set off with Millie and carried between them a large container filled with hot soup, a ladle, spoons and napkins. They were also on hand to give advice to the needy and continued to take in the occasional stray dog or cat.

William Wright

During the nineteenth century, the Admiral Rodney served as a farmhouse as well as the village inn. There was a cowshed, pigsties, stables, loose boxes, a carriage house and a granary attached to the rear yard, and also a rose garden and goldfish pond. To some extent, both the inn and its garden became the meeting place for the villagers according to the seasons.

In 1857 the Wollaton Rural Library was established here and boasted a membership of sixty-six participants. In 1877, the barn was being transformed by Revd Russell, who had a meeting room or institute in mind. He and Mr William Wright, Lord Middleton's agent, not only furnished the building but organized the daily and weekly delivery of newspapers, the loan of library books and the installation of a billiard table. Once the Village Institute was established, Revd Russell was elected president and William Wright vice-president.

Initially, the men of the village were pleased with the amenities until one or two members became dissatisfied and pressed for alcoholic drinks to be served and games of cards and dominoes by which to while away the winter evenings. Revd Russell was, because of his position, against such forms of

entertainment but in the meetings and committee re-elections that followed was outnumbered, even with William Wright's support. The result was that both these gentlemen gave way to the villagers' demands rather than have the Institute shut down due to lack of support.

William Wright died in 1900 but the villagers, although they may have opposed him, were grateful for the work he had put in to create a social centre for them. To commemorate his name, with the help of Revd Russell and the Middletons they raised the money to build the Institute that we know today, situated beside the tennis courts and cricket ground and which is still called The William Wright Institute.

Miss Gilbert and Mr McBain

For many years, Miss Emma Gilbert was employed at Wollaton Hall as head housemaid to the Middletons. She was a big, sometimes bustling and always maternal lady. 'Truly a mother to us all,' assured the late Mary Bell who at her last home in Capital Court, Coach Road, recalled her nervousness as she walked weighed down by luggage from the Derby Road tram terminus to the imposing formal entrance to Lenton Lodge one mid-week afternoon.

It was not Mary's choice that she should go 'into service', as becoming a maid or servant girl was known, but that of her parents who, despite their daughter's protests, enrolled her at a Derby-based domestic agency almost before she left school. Wollaton Hall was Mary's first placement, when she was fourteen.

Both sets of gates were locked when she arrived at Lenton Lodge, so she rang a side bell and after a minute a woman appeared and enquired as to the nature of her business. When she was satisfied with Mary's reply, the lodge keeper's wife unlocked the gates, admitted Mary, and locked the gates behind them. The lodge keeper's wife had been told Mary was due to arrive that afternoon and assured her that if she continued walking up Lime Avenue she would meet Miss Gilbert. Mary remembered the kennelled dogs barking and straining on their chains and free-range hens foraging around the gate lodge shrubberies. But the sight of Lime Avenue in its autumn foliage did little to ease her tension.

Over to her right were acres of long grass beyond which were two thick tracts of woodland. As she trudged, Mary heard the stags roaring and glimpsed them herding up the hinds. She was also on the point of tears because when the lodge keeper's wife had locked the gates behind them, Mary was doubly reminded that she would not be seeing her parents and sisters again for six months, as each maid or valet was allowed only two weekends off a year. So she would not be home at Christmas, but she assured me the Middletons were very good to all their employees' families and each Christmas sent them hampers containing a bottle of wine, cheeses, peaches, apricots, Wollaton-grown bananas and a haunch of venison.

Eventually, Mary saw someone on the avenue ahead of her. Someone approaching. A woman attired in a long dress and long coat. The woman was of course Miss Gilbert. 'When she came up to me and smiled, I suddenly felt safe and at home again. She shook my hand, briefly hugged me and picked up and carried my heaviest suitcases. And it was like that between us for the rest of our years together. She was the same with all of her staff. A lovely, lovely woman, Miss Gilbert.'

Mr McBain, Wollaton Hall's Head Steward. (F.W. Parkes)

Mr McBain at the north entrance. (F.W. Parkes)

Wilfred Widdowson discovered that Miss Gilbert had a sense of humour too, for one afternoon when the Middletons were away, Wilfred, then employed as a gardener, sneaked into the Hall through the servants' door (at the west side) and in the kitchen surprised the maid who, whenever she went down to the courtyards constantly teased him. Wilfred grabbed the maid in front of an equally surprised Miss Gilbert, dipped his hand into a two pound pot of gooseberry jam and wiped it all over the squealing maid's face. But as she handed the maid a towel and soap and turned on the hot water tap, Miss Gilbert also appeared creased with laughter while saying to her young charge, 'And serve you bloomin' well right, young lady!'

Low ranking maids like Mary were told that they must never be seen at or around the Hall's formal entrance unless they were scrubbing the steps. Nor must they appear in the Great Hall when a meal was in progress. Their place was the servants' quarters on the west side of the Hall and the courtyards where the food was stored and the clothes were laundered. For three mealtimes each day, however, Mary, under Miss Gilbert's tutorial eye, had to serve the head butler, Mr McBain, his meals.

The Great Hall and servants' kitchen were more or less lorded over by Mr McBain. At mealtimes Mary recalled he seemed to take over from everyone, whatever their rank. He was in charge of three footmen and the 'Hall boy', four butlers, four housemaids, three

Two views of the Salon, Wollaton Hall, as recalled by Mary Bell. (C. Shaw)

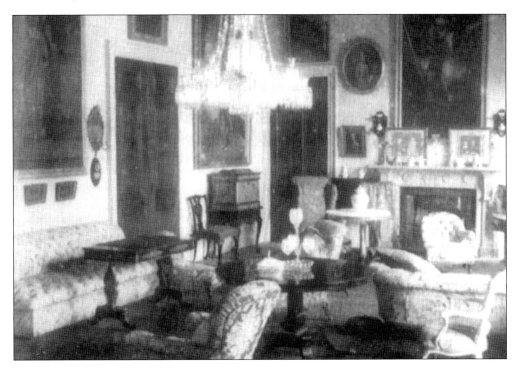

laundry maids and four kitchen and pantry maids. He was also one notch over Miss Gilbert and Mrs Hutton, the head cook.

Mary described how the low ranking maids were expected to serve the higher ranking servants between eating the meal put out for themselves. Mr McBain presided over the table and could be quite strict. When a maid walked to her chair, she had to stand in front of it for a second or two before she sat. This was expected of them all. And when Mr McBain left the table or returned to it, the entire servant staff stood and waited till he had paused before his chair before he sat. Once he was comfortably seated, everyone sat.

Because he was a Scot, Mr McBain was much favoured by Lady Middleton. Consequently, when the Middletons were in residence and entertaining guests, this gentleman was requested to stand in the minstrel's gallery overlooking the Great Hall in full Highland dress and playing the bagpipes. Slowly and with surprising dignity, Mr McBain descended the staircases to the Great Hall and continued his skirling on the pipes while the hosts and their guests were taking coffee, port, brandy or claret and the men, clad in smoking jackets, stood talking through wreaths of cigar smoke.

Reverting to thoughts concerning her own job, Mary mentioned that some afternoons she would be on village duty. That entailed taking a leather bag of mail down to Lodge Two then up Church Hill to the post office. The leather bag was zipped and locked with a special key and emblazoned with the Middleton family's coat of arms. At the post office, Mary was then handed the return mail in a similar bag which, on returning to Wollaton she handed to Mr Pilkington, the steward. Occasionally, Mary was allowed to take Lady Middleton's cairn terrier, Kyle, to the post office but what she dreaded was meeting the villager who walked surrounded by no fewer than twenty-two pet dogs, little pugs, lapdogs and poodles mostly. It was useless attempting to talk on the pavement because the dogs were forever barking and yapping.

CHAPTER 4
In Billy Archer's Time

The sheep being herded along Wollaton Road by Treton's Cottage with canal bridge (now Crown Island) in the background. (F.W. Parkes)

A smithy in the 1920s was situated where The Crown Hotel, Western Boulevard, now stands. The boulevard that we know today was a mixture of fields and allotment gardens interwoven with clear water springs. The Ilkeston to Nottingham road was the main thoroughfare and the Jubilee Campus is built on the bed of the canal which swept in a wide bend close to the boundary wall of Wollaton Park, then curved under the humpback bridge and lock gate to continue for a short way alongside Radford Bridge Road, before curving again behind what we recognize today as the houses and rear gardens of Charlbury Road.

It is difficult to imagine the junction of Middleton Boulevard and Wollaton Road as being part of Wollaton Park and enclosed behind the wall, even more so the Middleton Boulevard shops. But in the 1920s this was regarded as a rural lane leading to Wollaton village. Lines of oak and lime trees screened the parklands and rooks nested annually in the elms of March Wood and the walled field immediately after the canal.

For fifty or sixty years bill hoardings, a garage and fuel store have been established here. In the days I am describing, however, the field was walled with a five barred gate at one end and assigned as a permanent camp for the local Romanies. The wall can be seen in the accompanying photograph of sheep being herded along Wollaton Road.

Freda Parkes remembered the gypsy grandmother's funeral being held here when, in true gypsy tradition, the deceased matriarch was cremated with all her possessions in the brightly coloured living wagon or 'vardo' that had been her home.

Next to the field lived a gamekeeper and his family in a cottage sub-let by the Tretons. The cottage is remembered for the summer roses and wreaths of honeysuckle all but screening the windows. The gamekeeper probably worked for the tenant farmers, although at times he may have helped Billy Archer, whose established beats were within the park walls. The map of 1924 reveals a dairy and farm buildings situated in what were the fields opposite the park. Today the remains of this dairy can be seen flanked by a row of Lombardy poplars near the corner of Ringwood Crescent.

Opposite the wartime hardware and gardening shop, which is now (2001) a car sales lot and business called That Nail Bar, a high green gateway was positioned into the wall. The two wooden gates were always locked but a bell was fixed into the side if a member of the village community wanted to buy a brace of rabbits for which Mrs Archer, the gamekeeper's wife, charged sixpence. A hare cost one shilling and sixpence. She is remembered as a slim, darkish-haired woman who was always pleasant, yet gave one the impression that she cared little for life as a gamekeeper's wife and even less for living in a relatively isolated house looking out onto the coverts and oaks of Digby Avenue. The Archers were never without a dozen or so rabbits to sell because the parklands were forever

Treton's Cottage, Wollaton Road. (F.W. Parkes)

Wollaton Road between Lodges One and Two. (F.W. Parkes)

riddled with sizeable warrens and had always been, due to the sandy soils and in particular Arbour Hill.

The cottage stood back among the trees. It was surrounded by an iron fence and shrubberies. On the fence the rabbits were hung and deerskins stretched out to dry. Deerskins also adorned one or two of the nearby low tree branches and could be purchased for three shillings each. The antlers of red deer stags and fallow bucks were displayed along the exterior walls of the cottage and the doors and porches of all the outbuildings. A really fine symmetrical pair from a bloodstock stag that Billy Archer had previously admired were the only antlers adorning the cottage's interior and were positioned above the sitting room fireplace.

To the rear of the cottage several working dogs, springer and cocker spaniels and black Labradors, barked from the well-concealed pens. Ferrets were kept in hutches. Free-range hens, mostly Rhode Island Reds, searched through the leaf litter.

It is not known when this cottage was built or how many generations of the park's gamekeeping families lived there. But a family named Jacques were probably in residence before Billy Archer, his wife and son Claude. From the cottage a sandy track struck off at an angle of forty-five degrees and joined with Digby Avenue. Presumably, the track would have crossed what is now a playground of Middleton School, then proceeded across Harrow Road and the Glenn Bott playing fields to join Digby Avenue, about opposite the Gorsebed where Billy Archer's pheasant pens were set up in good numbers.

Billy Archer spent his boyhood around the streets and alleys of Forster Street, Radford,

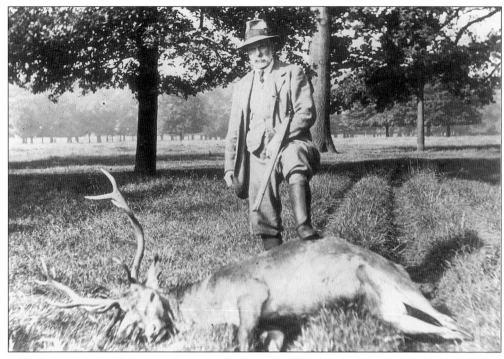

Billy Archer with a culled stag in the Digby Avenue area. (F.W. Parkes)

although his grandfather and father may well have worked at Wollaton. No doubt as a boy he used to climb over the wall and explore the nearby Lenton Wood and Dead Dog Wood before, perhaps, being routed by his predecessors. Nor was it usual for titled landowners to employ local men as game-keepers, because they would know the poaching fraternity and in all probability have been sympathetic to their family predicaments. Other than housemaids and laundry-maids, however, The Middletons seem to have been willing to take on local people and provide them with an income. They also obviously trusted their gamekeep-ers and Billy Archer lived up to that trust. A man of small to medium height and jaunty stride, Billy Archer sported the traditional moustache and sideburns. Except for when he was rabbiting with nets and ferrets, which

was two or three times a week, he wore a trilby and suit with plus fours.

When Freda Parkes produced a snapshot of Billy Archer wearing his 'Sunday best', I immediately mistook him for Lord Middleton because he was wearing a wide brimmed trilby, black or dark brown pin-striped suit, immaculately pressed trousers and highly polished shoes. In the hand near-est to the camera he clasped a black walking stick with a silver knob on the end.

After his daily chores, Billy Archer pre-pared venison and rabbit offal for the dogs and ferrets, and around four, his wife milked the single cow the Middletons' agent had agreed they could keep. Around seven in the evening, he would then set off up Digby Avenue to meet his friend, the coachman George Parnill, and together they would cross the park to the Admiral Rodney. Here,

with their pints before them, they would play darts and dominoes and with the village constable hatch plans on how best to thwart the poaching gangs. The Admiral Rodney's landlord, Percy Hickling, was occasionally given a haunch of venison or deer's liver and, no doubt, Billy was served the free extra pint or two in exchange.

Reverting to life around Billy Archer's cottage, Wilfred Widdowson recalled how Billy was granted a hay allowance for his cow, but he would pile up the manure and, via the land agent, sell it back to the estate for manure at the price of a pound for a pound!

Billy's wife seems to have eaten the midday meal alone most of the time, or at the weekends and school holidays with their son, because Billy around noon slipped out of Lenton Lodge via the cattle gate entrance and spent an hour or longer in the Rose and Crown on Derby Road. He would always take two brace of rabbits to the gate lodge, drop one brace in the long grass, then carry the other to the landlord. When he returned to the park, he would then pick up the brace he had left, begin walking through the woods and no one would be any the wiser.

During the spring and early summer, Billy Archer's under-keepers were assigned to the task of controlling rabbits because the head keeper's main interest reverted to breeding pheasants. Consequently, acre upon acre of parkland had to be covered and the nests recorded, the pens made, the poults transferred to the broody domestic hens which were kept in coops throughout the glades of Thompson's Wood, the Gorsebed and Lenton Wood. For the keepers this was an exceptionally busy time.

A man paying Wollaton a return visit long after he had set up home in New Zealand enthused that the keepers could always tell when someone was trespassing in the woods because the pheasants were so many you could hear them protesting even when you were working in the gardens. He also remembered Billy Archer and George Parnill's evening visits to the Admiral Rodney and described them as being 'immaculately turned out in smart shooting suits, stiff collars and ties, knee boots and leggings or gaiters which their wives had blackened at their hearths the night before.' He also found Billy Archer's sheds fascinating places, fitted with every tool of the countryside one could think of, as well as dismantled pheasant coops and rolls of wire netting. He also knew that when a gamekeeper's dog was past its dotage, it was shot and buried, which in Wollaton's case is how Dead Dog Wood came to be so called.

The collective headquarters of the gamekeeping staff was situated in the stable block to the right of the formal entrance. There were two rooms: the gun room where the shotguns and cartridges were kept and the former regularly cleaned, and the game hanging rooms where braces of woodcock, pheasant, partridge, mallard and wood pigeon were hung on a swivelling rack in readiness for the housemaids to come down from the Hall with His Lordship's or Miss Gilbert's daily requirements.

Gin traps, mole traps and other vermin control traps would also be kept in the gun room, probably in store cupboards. Billy Archer would of course see George Parnill and probably go to his flat for a cup of tea, and the photograph I have seen in a private collection depicting the helmeted village policeman posing alongside three or four pretty laundry-maids suggests that flirtations and cajoling took place, especially since the laundry with its huge brick boiler was situated next to the gun room but with its access on the outer side of the stable block's west wing.

The ironing room was situated on the second floor of the laundry block and as he talked with the maids, Billy would have seen the wet washing being piled on to a wooden platform before being hoisted by rope and pulley to the room above. The drying yard was situated father along the block and here all the daily output of clothes were hung out on the washing lines, weather permitting.

At this stage, the end of the stable block was used as a blacksmith's shop and adjacent to the drying yard and dairy is a wall-side milking house. Billy Archer would have seen much activity taking place around the courtyards in his time. But fortunately he was not a member of the estate staff who had to report to the works cabin at eight each morning. If Lord Middleton was in residence, he not infrequently visited the works cabin a little before eight and in the winter stood with his hands behind his back and his back to the fire. Relaxed he may have appeared, but on the table in front of him, my correspondent tells me, he placed his pocket watch and if a workman arrived after eight that workman had some explaining to do.

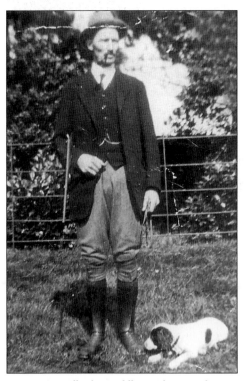

George Parnill, the Middletons last coachman, rough-shooter and friend of Billy Archer. (F.W. Parkes)

CHAPTER 5
The Poaching Affrays

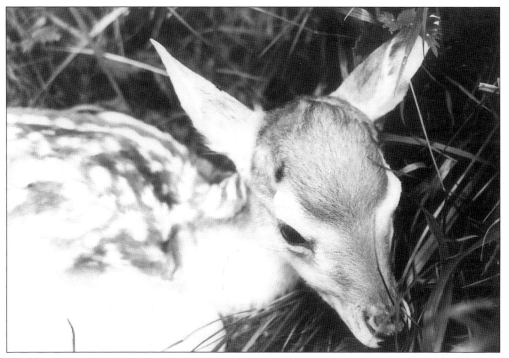

A day-old fallow deer fawn. Poachers lifted them as young as this. (From the author's collection)

Although some Wollaton poachers cycled in gangs from Ilkeston after raiding Squire Edge's estate at Strelley and the Mundys' extensive parklands at Shipley, the regular poachers lived close to the park in Canterbury Road, Radford. However, at least two lived a little farther along in Denman Street and possibly knew Billy Archer's family and relatives, if not the brisk and upright gamekeeper himself.

Canterbury Road and the boundary wall of Wollaton Park were less than a quarter of a mile apart and within sight of Ilkeston Road, along which the poaching families walked daily. Where the gasometer looms near the corner of Triumph Road today, a marshy tract of land divided the road from the canal lock gate known locally and rightly as Poacher's Lock, by which the poachers crossed the canal and hoisted

A favourite quarry of local keepers and poachers.

themselves over the wall and into Wollaton Park.

Lenton Wood, a wilderness of bracken fronds, oaks, silver birch, lime and pines, was their nearest target, where many pheasants and fewer woodcock bred. The poachers took game indiscriminately at all times of the year, a fact once proven by a part-time joiner who was occasionally employed by the Middleton estates. He was asked one day to call at a house in Canterbury Road, presumably to supply an estimate for a job. When he tapped at the door and was told to enter he saw seated at the kitchen table, and surprised because she had been expecting someone else, the wife and mother of the house. She was shelling peas surrounded by braces of pheasant and mallards. These, she could have argued, her husband had shot and snared in the marshy tracts beside the canal. But the same could not be said for the newly born fallow deer fawn tethered to one of the table legs! Fawns are born in June or early July, which indicates that so far as the Canterbury Road poachers were concerned there was no closed season.

A man now in his eighties remembered a Denman Street poacher who always wore the traditional brown overcoat with deep poacher's pockets that were seldom empty. Usually there was a brace of pheasants in there or a couple of rabbits. These the poacher did not sell; instead he gave what he did not want to the neighbourhood's poorest families.

Then a Radford boy, who on a bicycle delivered the weekend joints of meat to the stable block residents every Saturday morning, apparently went to a local billiard hall one Saturday afternoon and mentioned having seen pheasants in the park 'just about everywhere you turned'. On the following

56

Monday morning before it was properly light, there was a knock on the butcher's shop back door. Puzzled, the butcher unbolted the door and was confronted by four or five men standing in the porch with no fewer than thirty-seven pheasants dangling from the strings entwined around their fingers. 'How much will you give us for this lot?' one of them asked, whereupon the butcher named his price, the deal was made, and no further questions asked.

A past resident of New York Cottages also remembers the foggy afternoon that a neighbour shot a brace of pheasants and stood with them in the middle of a Gorsebed rhododendron thicket for an hour while the staff cycled around the park checking the thickets but without success. In the winter dusk the poacher climbed the wall and crossed Wollaton Road to New York Cottages. Grinning and shouldering his shotgun, he then gave the thumbs up sign to my informant who was shutting up his father's hens for the night.

Billy Archer and his colleagues, Jesse Oliver and Charlie Edge, were not always thwarted however, for sometimes they were tipped off about the planned poaching forays and awarded a brace of pheasants to their informers. They put taut trip wires across the woodland glades but to my knowledge never used man traps, although Strelley Hall, the neighbouring estate to the north-west, claimed at one time to have the largest set of man traps in the entire country.

Sometimes the poachers were caught red-handed. More than one was downed by the trip wires. But the majority were chased and Billy Archer's fleetness of foot became legendary throughout Wollaton and Radford. Young men told of how they had ran with a man of 'medium build and flowing grey hair' hard on their heels.

Woods patrolled by both gamekeeper and poacher. (From the author's collection)

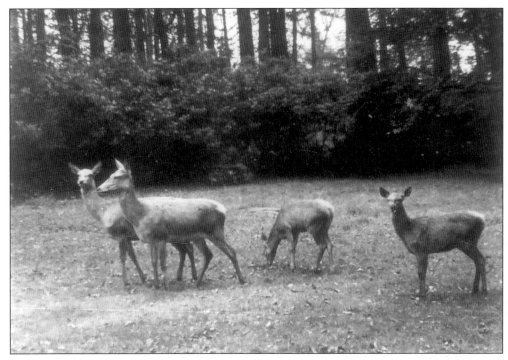

Red deer hinds with calves foraging for acorns beside the Wellingtonia Plantation. (From the author's collection)

The actual incidents in which the game-keepers and poachers came to blows were comparatively few but I have it on good authority that Billy Archer was chasing a lad through the Lenton Wood Coverts when a rhododendron snag gouged out the lad's eye. Blinded, the lad sank to his feet and Billy's anger turned immediately to concern. He took the lad back to his cottage and sent an under-keeper to the village doctor. In the meantime, Billy's wife did what she could for the lad in his immediate state, although unfortunately he was blinded in one eye for life.

My Radford-born friend, Arthur Raynor, used at one time to scale the Wollaton Park wall by Poacher's Lock but with his friend and a punch-bag, because he intended to learn to box to defend himself and train as a boxer. Billy Archer came across the boys one afternoon, lit a cigarette and stood watching them. When finally he intervened, Billy asked them if they knew one Radford family and then another before giving his consent for them to use the park for that one purpose provided they were not seen by anyone other than his gamekeeping colleagues. Understandably, Billy Archer would rather they had taken the punch-bag back over the wall than a brace of pheasants.

CHAPTER 6

The Splendour of the Stags

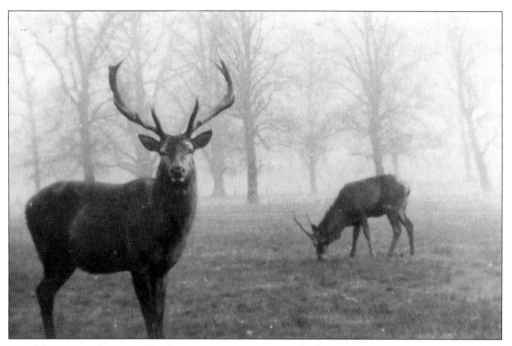

A red deer stag with a year-old male or 'pricket' grazing in the background. (From the author's collection)

During the early 1920s, about thirty country estates in Nottinghamshire kept deer both as a source of protein-rich food and ornaments. The smallest deer park in England was situated about four miles from Wollaton at Bagnall House Park, Basford, where Thomas Hancock kept four fallow deer, one buck and three does, in a two or three-acre walled enclosure.

Given their acreage of grass, most parks seem to have been overstocked in Edwardian times and Wollaton was no exception. Harold Walton, who was employed as an apprentice under-keeper to Billy Archer, recalls there being at least fifty red deer stags of various ages and sizes and just as many fallow bucks.

The Russell sisters and Lady Middleton were keenly interested in the deer herds, whereas to the keepers the deer represented work, particularly in the early autumn culling season when numbers had to be

reduced to keep the herds to a manageable level. Once a stag had been shot, it took four men to lift it on to a flat, horse-drawn dray which was really the only means of conveyance. I was shown snapshots by the late Steve Oliver of Billy Archer, towering Charlie Edge and Steve's father Jesse standing beside a dray with the workhorse, Kitty, harnessed between the cart's shafts.

Jesse Oliver was grey bearded and resembled the Western film star 'Gabby' Hayes. Moreover, on his weekend evenings off Jesse occasionally went to the early cinema shows and became impressed by cowboy star Tom Mix, who demonstrated the art of shooting from the hip. Wilfred Widdowson remembers the day when Jesse shot several rabbits in this manner and startled his sidekick, Billy Archer. During the autumn culling season, Billy tried shooting at a stag from the hip which resulted in his aiming to high and shooting off half of its antler. Disgusted with himself, Billy resolved never to attempt such a foolhardy act again. Jesse Oliver, incidentally, had the reputation for skinning a deer faster than anyone who had worked at Wollaton before him. It was said that he could skin a fallow doe in eight minutes flat.

Further snapshots showed that there were some quite magnificent stags in the park and I remember one picture of two stags standing flanks high in a field of barley. Their weight, body size and span of antler were impressive to say the least. When the stags and bucks were shot, the finest 'heads' or pairs of antlers were usually claimed by the landowner or a member of his family for the purpose of mounting them for display on a varnished shield so that they could be admired in the salon or gallery of their country seat. On the day scheduled for a deer drive, most of the estate workers and gardeners were enlisted as beaters. The estate stewards and grooms rode on horseback. All the beaters, whether on foot or horseback, were cleared from the area by the gamekeeper blowing on a whistle as the stag or buck came towards him, thus warning them to stay out of the firing range.

The gamekeeper, and Billy Archer in particular, fired from ambush. Usually he was positioned in the boughs of a tree or a clearing among rhododendrons. To prevent deer from entering specific belts of woodland, white rags were tied to the fence gates to unnerve them.

Unfortunately, the long range rifle with the telescopic sights was still to be designed. Consequently, with a shotgun or the old Naval rifle which Billy Archer often used, the keeper had to get relatively close and aim at the forelock to bring the stag down with one shot.

Deer culling in this manner was usually spread over two or three weeks. The stags and bucks were culled in September, the red deer hinds and fallow does in December. Billy Archer always claimed that the deer could smell the blood on his clothes from each morning's cull and in the afternoons walked out dressed in his wife's long coat, scarf and, some insist, even her hat. His shotgun was concealed within the long coat. Understandably, his under-keepers, Jesse and Charlie, used to tease him and tell him he reminded them not of Tom Mix, but another film star, Old Mother Riley!

When the venison was jointed, every member of staff was given quantities to take home. The choice cuts were taken up to the Hall, although traditionally the gamekeeper and under-keeper were allowed their choice cuts, along with the pick of the finest antlers to be mounted on a shield. I can personally vouch for the fact that venison liver is a great delicacy and was as much prized then as it is today. Many such livers there-

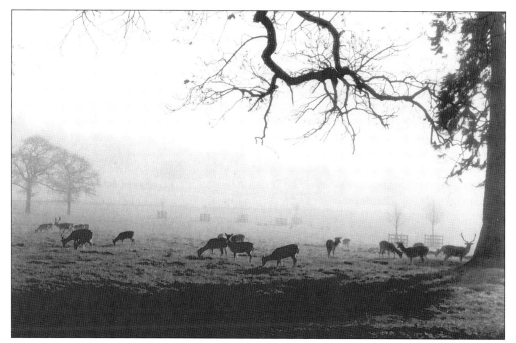

Pilkington's Paddock from Hurst Avenue; fallow deer herd in winter sunlight. (From the author's collection)

fore were taken up to the Hall on trays and others, again, distributed among the staff. With so many deer in the park, Billy Archer could not possibly recognize them all as individuals and because of this missed seeing a 'switch' stag. This is a stag that carries an aberrant antler, lacking points or tines but terminating in a singular spike arrangement at the top. The 'switch' was not recognised until several stags were found dead about the park. On investigation, their fatal injuries appeared to have been through goring but also through being singularly pierced. When the 'switch' was discovered Billy Archer shot it and the goring ceased which proves that he was right in his assessment. Stags occasionally fight to the death during the autumn rutting season, or die from injuries caused by interlocking antlers during battle.

In the hollow by Deerbarns Wood one autumn morning, a keeper found and took Billy over to a stag that was dead in the bracken fronds. A short distance away, two stags knelt on their forequarters for each had been slashed by a rival to the extent that their entrails were dragging on the ground. Billy Archer had no choice but to dispatch them both, after which he explained that it looked to him as if one stag had gored another in the first battle, for an 'oestrus' hind survived but had been challenged by a second fresher stag. Nevertheless, that battle resulted in the loss of three stags.

Unless people were involved in deer management, they seldom, if ever, experienced deer in this way but like the Russell sisters and their friend Lady Middleton enjoyed walking or riding out occasionally just to admire the frequently discussed splendour of the stags.

CHAPTER 7
Village Voices

Snow layering the formal gardens. (F.W. Parkes)

Wilf Widdowson

Wilf Widdowson knew the park, the ornamental and kitchen gardens almost as well as he knew the palms of his hands. His memory for detail is testimony to that. For instance, he recalls a seat positioned in a recess of Camellia House with the words 'Heavy Fall of Snow 18 April 1908' inscribed on the underside; Fred Meats, who lived in one of the courtyard flats, spraying the camellias every day of the year at four in the

afternoon; the gales in the autumn of 1928 which uprooted several Cedars of Lebanon on the south lawn.

Wilfred then recalled the dark days of midwinter when gas lamps were fixed to the chandeliers suspended from the main rooms in Wollaton Hall and two gas lamps were lit either side of the main entrance. A gas main had been extended from Lodge Two up to the stoves in both the Hall and courtyard flats. The staff, I should add, could take as much coal as they required. The bunkers for stor-

Gale damage on the lake island. (From the author's collection)

ing both coal and coke were situated on the west side of the Hall where the gents' and ladies' toilets are today. Throughout the winter months, Wilf remembers there being a constant trail of wheelbarrows being trundled from the courtyards to the Hall west doorway, as the valets and workmen went to fetch fuel for the many and varied fires.

After a hard snowfall all the estate workers were handed spades and told to form into groups, then clear the main avenues from top to bottom. During one particularly cold spell, Wilfred and his gang were assigned to the path around the lake on which the ice layer was so thick that the men at break-time piled brashings and kindle, then boiled a kettle of water on the ice surfaced fire so that they could make tea.

In 1926-27 two large cracks appeared in the bed of the lake, but this did not become apparent until the water level began to recede. When eventually the land agents rowed out and discovered the cracks, Wilfred was assigned to the work gang who were instructed to drain the lake water into the old decoy pools in Thompson's Wood, then block the inflow from Martin's Pond. Over the next few days the men filled the cracks with puddle clay, which was the same as that used for 'puddling' the leaks that occasionally appeared in the bed of the canal. When the cracks had been filled, Wilfred and his work mates shovelled masses of black glutinous mud around the water lily beds, thus ensuring their stability when a fresh flow of water from Martin's Pond was released into the lake bed.

Cattle and Ducks

Between the west side of the Hall and the lake, the lake field slopes gently to the edge of the moat. At one time this field was fenced with post and rail and grazed by Guernsey cattle. The strip of alder-fringed bank between the moat and the edge of the lake has for many years been called the Duckride – 'the green ride where the ducks gather to breed and preen'.

One correspondent remembers 'those lovely ornamental Mandarin and Wood ducks all sporting on the water around the island and five or six Anglo-Chinese geese grazing along the Duckride, which was fenced at both ends, to allow such wild species as the mallard and tufted duck to breed without disturbance.'

In common with most landowners, the Middletons encouraged the growth of water lilies which, when harvested, were sent to London market where they were waxed and sold to adorn ladies' hats or threaded together to form wreaths which were laid over coffins.

Listening to Bill Ash

Born in 1907, Bill Ash spent his boyhood at the family home which was one of the New York cottages. His father was employed as a woodsman and general estate worker in Wollaton Park. Bill remembers the barn owls which used to hunt across the fields between Woodyard Lane and the canal bridge at Radford. (Today this same location would best be described as extending from Lambourne Drive to the Crown Hotel, Western Boulevard). He also loved to wander out at dusk to listen to the tawny owls hooting from Harrison's Plantation and on the occasional evening in midsummer sat

The farmyard and barn around 1920. (F.W. Parkes)

64

among the bracken fronds in the small copse between the canal and the Brown's Sawmills workyard, for this, as I have already mentioned, was the breeding covert of at least one pair of nightingales.

Like every child in Wollaton, Bill attended the village school and says of his schoolmate Bob Jenkins: 'Little Bob got more canings than anyone else in the entire school, yet when I met him in his mid-forties, Bob still insisted that he thought their schoolteacher, "Gaffer" Jordan, had been the best schoolteacher in the country!'

When they were in exploratory moods, Bill and his friends used to walk along Woodyard Lane north to Aspley Hall. 'There were no footpaths as such, just lovely spinneys and herds of dairy Shorthorn cattle. On the right, as you walked with your back to Wollaton, was a wood called The Dover, although we never knew why. And in the Shepherd's Wood before the Bakers and the Wilsons moved into the two isolated cottages, there was a collier called Thompson lived in one and the Quiney family in the other.

When the National Strike occurred in 1926 and all the local colliers downed tools along with everybody else, the ponies from the Wollaton and Cinderhill collieries were all put out to graze on the fields around Aspley Hall and Shepherd's Wood.

If you wanted to go to Nottingham, you had to walk there and back, until they laid tramlines down Aspley Lane and along Ilkeston Road as far as Radford station. Sometimes though a carter would give you a lift. It might have been a hardware merchant's conveyance or a milk cart, but you couldn't afford to be choosy. You just climbed in, thanked the man and hoped, if you were going into Nottingham, that someone else would stop and give you a lift back. And sometimes they did.

One man who never minded walking – or wheeling his bicycle anywhere – was an itinerant mole catcher who, with his fund of stories about farmers, gamekeepers and woodsmen, used to come to our cottage for a few nights when he was working for Lord Middleton. Miraculously for those times we had a spare bedroom, so my mother used to cook his meals and he'd stay for a few weeks, or even a month or so, and then move on only to return a year or eighteen months later.

I can remember the first car being driven through Wollaton village and a proud day that was for Mr Pilkington, Lord Middleton's steward. The second car was driven by Squire Edge of Strelley Hall. He was visiting Revd Russell and then went on to attend a function being staged by the Middletons at Wollaton Hall.

Each of the four New York cottages was a three-bedroomed dwelling with a coal house attached and a copper standing in the outside yard for the purpose of boiling pig-swill. Other outbuildings were divided into the toilet, tool sheds, and pigsty, beyond which stretched an orchard and vegetable garden.

The Browns, who owned the sawmills, only lived at The Lawns occasionally, for as a lad I remember the Hardin family living there. Oh, I remember Mr Brown. He was a real gentleman. A clean-shaven fellow who always wore plus-fours, and when the better-off folk started buying their cars, Mr Brown and Mr Hardin were among the first to drive down Woodyard Lane in one.

Incidentally, the rent my parents paid for our cottage was sixty shillings a year and we used to supplement our income towards the rent each autumn when Lord Middleton, or one of his estate stewards, let it be known that the estate would pay one shilling and sixpence for every "strike" of acorns that was

Banners Field, Bramcote Lane, as Bill Ash remembered it. (F.W. Parkes)

delivered to Archer's Farm. A "strike", by the way, was a bucket filled with acorns to feed the Middletons' deer and pigs. Usually we had collected three buckets of acorns in as many weeks, and it seemed as if all the less well-off folk in Wollaton were collecting them. Anyway, the four shillings and six-pence that Billy Archer's wife paid us for those acorns went into our rent books, so in a way the fact that the Middletons kept deer and pigs helped us keep a roof over our heads.

My dad was a good friend of Billy Archer's and both him and us used to go beating for the pheasant shooters, especially when they were doing the Aspley Hall estate. Now Mr Eben Hardy lived at Aspley Hall when I was a lad and he rented all the shooting from Lord Middleton. The spinneys there were alive with rabbits and there were any num-ber of hares. All the woods, Horsehoe,

Robin's and Shepherd's, harboured the pheasants and occasional woodcock, but it was customary, for reasons best known to the gamekeeping staff, to leave Robin's Wood until the last.'

Before he left school, Bill began to earn a little money by helping the milk delivery-men who set off each morning from Alsebrook's Farm. There were three ponies and three milk floats involved in the milk deliveries during this time and at the week-ends and throughout these mornings of the school holidays, Bill went with each driver as far afield as Sherwood and Arnold. The Alsebrooks sold and moved from their farm when Bill was leaving school at around thir-teen years old, but fortunately a Mr Harriman took over one of the milk rounds and hired Bill on a full-time basis. Just after his nineteenth birthday, Bill decided to start

his own milk delivery round, but instead of a pony and trap, he could only afford to buy a sit-up-and-beg bicycle. Yet, undeterred, he set off from New York Cottages each morning carrying a clean bucket on each handlebar and cycling to the dairy owned by Moor and Son, which was situated on Independent Street, Radford. Thus the young businessman set about making a little money for himself and within several years he had made enough to afford his own pony and trap.

Eventually, Bill learned that the white farmhouse near the Rectory and overlooking Martin's Pond was up for sale, along with twelve acres of land that the tenant intended to lease out. The farmhouse, twelve acres of land and lake had all been included into the small estate, known then as John Martin's Farm, but over the years the holding had changed hands several times and when Bill Ash was a young man, it was called simply Dairy Farm and owned by Mrs Walker. Negotiations were soon in hand and Bill leased the land for three years from Mrs Walker. That said, he certainly began extending his round, for there was both a bottling plant and sterilizing unit at Dairy Farm, although stabling proved difficult, so Bill stabled his pony in the Brown's buildings on Woodyard Lane within a few strides of home.

Bill's only afternoon of relaxation occurred on a Sunday when he would call for his friend, Vince Hodgkinson, whose mother and father were the landlords of the Admiral Rodney, and it was while he was out walking the lanes that Bill met the girl who was to

Bill Ash daily saw cattle trooping down Wollaton Road for milking. (F.W. Parkes)

Cattle and dew ponds with Wollaton Hall in the background. (F.W. Parkes)

become his wife. By the time that Bill was twenty, the couple had married and were preparing to settle down.

Despite Revd Russell's occasional intervention, Bill spent quite a lot of his time around Martin's Pond. 'Oh aye. It wasn't reedy then like it is today. The island was in the middle with a few reeds around the sides, but it was completely surrounded by water. A pair of swans always nested on the island and came off each year with six or seven cygnets. I've fished it as well. Had a pillowcase of bream out of Martin's Pond. Besides bream there were roach, perch and rudd, and a pike that swam away with someone's tackle in its jaws.'

Where the allotments are today, stood a row of sheds. Here the high explosives used at Wollaton Colliery were stored. There was always a man on security, as you can imagine. And the sheds in general were known as the Powder House. When Bill's three-year lease with Mrs Walker terminated she chose not to renew it, for the building firm of Bush and Cragg had made her an offer she could not refuse. However, Lord and Lady Middleton had by then passed away and the affairs of the village were to be changed almost beyond recognition.

CHAPTER 8
Village Incidents and Recollections

Early Mornings

The crowing of the cockerels and the voices of stockmen goading their cattle from the pastures and into the milking sheds were the sounds you awoke to each morning. Smudges of bluish-yellow light penetrated the gleam as the gaslights were burned. Kettles were places on the hob, shoes and coats were lifted for inspection and the family pig squealed with excitement when you placed a bucket of mash in his sty; then you carried a ladle or two of grain over to the fowl pen. Horses were harnessed and led from the stables, with whiffs of hay and chaff pleasantly wafting before the nostrils of anyone walking by.

The conversations of the men revolved around horses, dray spokes and wheels, the previous evening's billiard game at the Institute or the seasonal splendour of Mr Dexter's chrysanthemums. The women talked of cooking, cleaning, buying clothes

George Carrington and Harold Walton in their younger days. (Mrs Carrington)

pegs and whose turn it was to arrange the church font flowers that week.

Eventually, the rhythmic clop of hoof beats as the carters and draymen trundled by the window made the men aware that they too ought to be leaving home and heading for the colliery, canalside, farm, woodyard or Wollaton Park where they were employed.

The Dexters

The Dexter family lived on Noggins [Bramcote] Lane in the large white house with its five bays and green painted shutters fronted by a five-barred gate and gravel drive, from which you turned off to knock at the door marked 'Servants' Entrance'. Occasionally, the children glimpsed one of the maids who lived in and worked at the house.

Mr Dexter owned a big nursery where you could buy fruit, vegetables and eggs. He also sold his wares from a number of stalls in Nottingham Market. Everything was home-grown. If he happened to see you leaving with a basket of fruit that your parents had sent you to buy from the head gardener, Mr Dexter would call you aside, then walk away and return within a minute or two with some delicacy, like a handful of freshly picked blackberries, which he'd wrap inside a lettuce leaf before placing the bundle into your hand.

Just a few hundred yards from Mr Dexter's house the Tottle Brook wound below the slopes of Bramcote Hills and, although it was a wild growing plant, the watercress used to be properly cultivated by several of his horticultural staff, who at times showed their displeasure if they found someone gathering the cress without having first sought Mr Dexter's permission.

Musical Evenings

Children were not allowed out to play on dark winter nights, but entertainment for the adults was very much to the fore in this comparatively small community. Those who were invited to the musical evenings, staged by the Russell sisters in their courtyard flat, usually met in the village square then walked down Church Hill to the gates of Lodge Two. It was the estate worker Jack Lane himself who answered the summoning bell and admitted the guests into the park. Then, after enquiring about the time they expected to be returning, he would tell them to tap on one of the Lodge windows and he would open the gate to let them on to Wollaton Road.

Billiards at the Institute

'I cannot speak for the rest of the villagers, but I remember meeting other young men and playing billiards in the Village Institute, while from the Rodney came the hum of voices as Woodbines and Robins were smoked, beer drunk and dominoes played by the usual crowd of regulars.'

Skating on the Pond

'During a winter's heavy snowfall, paths and pavements were cleared of ice and snow and on their days off, those who could afford ice skates wended their way across the field to the solidified surface of Martin's Pond. It was lovely seeing young couples out there skating by moonlight. Ice skating was then very much a part of the winter village scene, but the interest in it locally was never really revived after the Second World War.'

Playing Out

'Shrove Tuesday was whip and top day, so far as the village children were concerned, and the day ended with a special tea and a concert laid on at the old schoolhouse. Then as the evenings became lighter, we played out longer, usually in the village square where again we played whip and top, skipping or shuttlecock and battledore.'

The Oddfellows

Every Whit Monday, the Oddfellows Society would hold a church parade at the head of which the bearers carried a silken banner displaying the Good Samaritan ensign. But the highlight of the Oddfellows' year was the 'Feast Sunday Supper' cooked by Mrs Hodgkinson, the landlady of the Admiral Rodney.

Colliery Row

From a correspondent describing the stretch of Trowell Road extending from the canal bridge to Balloon Crossroads, we learn that 'Horses, drays and the occasional canal barge created a sense of industrialization, for across from the willow break [Glover Avenue] was Colliery Row, a straight road leading directly to the Wollaton pit and colliery outbuildings. There would be horse-drawn coal wagons, stacked sacks of coal and grimy coated carters and deliverymen cheerily greeting everyone they passed, sunshine or snow regardless.

The large cottage and outbuildings on the corners of Colliery Row (now the site of the Roebuck public house) was the home of the Allen family, who kept hens and ducks. The ducks, a flock of white Alyesburys, you'd see daily filing across the road to the canal which ran alongside it.'

Colliery Row, now Torville Drive. From the gateway to the left, the Allen family's ducks used to cross to the canal. (F.W. Parkes)

Colliery Row had been designed in the style of a Victorian or Edwardian esplanade. On the left-hand side, as one walked towards the colliery, stood a distinctive row of red-brick cottages built in 1874. The cottages housed the families of the administrative staff or 'top men', as those whose occupation required them to work above ground were known. The front doors and windows faced the canal and the rear gardens backed on to the hayfields. A row of horse chestnut trees flanking the wrought-iron fence which extended from the canal bridge to the gates of the colliery yard provided the 'esplanade' atmosphere. But very few colliers used this formal route, for the majority of them walked from Bilborough, Basford, Aspley and Radford along their extensive 'pads' to join the canal towpath and enter the colliery yards from the direction of the slag tips and the adjacent stretch of derelict land known as 'The Roughs'.

On the Trowell side of the LNER railway bridge were more fields forming a vale with some fine oaks and elms on either side. Over to the right, a small lane led away from a stile and narrowed into a footpath which crossed the fields and took the walker by Grange Farm and across to St Martin's church and Strelley Road. Those few village folk who live in Wollaton today recall a gentleman dying of his injuries thereabouts after he had fallen from a horse which refused to leap one of the stiles. As one continued up the hill to what we know today as Balloon Crossroads, the occasional cottage could be glimpsed between the trees and hedgerows. 'It was a roadside of April primroses and cuckoos calling' writes 'CA', 'and there were herds of Dairy Shorthorn and Ayrshire cattle grazing the lush grasses of the fields on either side.'

Ascoughs Farm

Vernon Jackson, who spent his boyhood at a holding beside the canal within a few strides of Balloon Wood, remembers walking to school and passing two old cottages in the village square that were lived in by the Haggs and Harris families. The men of both families worked at Wollaton Park. His walk along the Trowell Road took him twice daily by the five-barred gate of Ascoughs Farm which stood on the site of Bridge House. 'Ascoughs was a working farm in every sense of the word. A little further along between the canal and the railway was a smallholding farmed by the Hazzards, but around 1930 the Davidsons moved in and grazed horses on the lovely green paddock which sloped down to the canal.'

They may have bred a few horses, but the holding itself became a riding school. Rather than call it Davidsons, though, it became know as the St Leonard's Riding School and was well patronized.

'The Davidsons were good hearted people who kept fowls and geese as well as a sizeable stable of horses. The entrance to their holding was situated opposite the Trowell Road supermarket, just about where Moorsholm Drive leads off from Wollaton Road. Sometimes when my father sent me on an errand to Davidson's place, the old man, if he happened to see me, would walk over and say: "Hello there young Vernon. I haven't given you anything for a while." And with that he would put a sixpenny piece gently into my hand or give me a goose egg to take home for my tea. On one occasion he gave me three goose eggs which I took home to our smallholding and I put them under a broody hen. We started our own goose flock off that way.'

Vernon, for reasons best known to himself, became interested in water levels and water supplies in general. 'There used to be a water butt standing beside every cottage and it used to be filled to the brim with rainwater. And in the communal yards you had to pump the water by hand. There was a large underground reservoir in a field on Blackbird Lane and close to Catstone Hill. The reservoir keeper's house was called the White Lodge and from this dwelling was laid one of the most prominent water mains in the district. There were also several deep wells scattered between Strelley and Wollaton and eventually the village and Wollaton Hall became connected to the main supply. The water pipes I remember were made of iron. Gradually the pipes were extended to include the houses at Brown's Sawmills and also the New York Cottages and when eventually the Admiral Rodney had taps and sinks fitted, it was almost cause for a celebration.

As children we had followed the village lamplighter along the roads when we left school at half past four on a dark winter's afternoon. The lamplighter's name was Mr Crookson, and to us he appeared tall and bearded. Yes, I can see him now wearing his trilby hat and long, dark overcoat. "Better than me owd job down Wollaton pit," he used to tell us, then add – "Course, the money ain't the same but money's not everything now, is it?" Mr Crookson lit the Wollaton village lamps until gas was laid on to every homestead around 1925. "Well, I've outlived me usefulness now. Modern methods are catching up with me," the lamplighter told everyone when his services were no longer required. And so he retired to live a few peaceful years in a village that was to experience a good many changes in the years ahead.'

Water was laid on along Woodyard Lane. (F.W. Parkes)

Local Countryside

John Farnsworth, with Eunice his wife, remembers the Lenton Abbey Recreation Ground being 'an unruly tract of heathy fields with gorse bushes hiding many of the sandpits.' Where the park wall swung north near the present site of The Priory Hotel, long layers of sand formed steep banks along which a rough track, known as Parkside, took the walker alongside the wall and by Waltons Farm and Charlie Edge's cottage to Noggins Lane. Today, sections of this sand track are occasionally uncovered when householders are digging out their gardens close to the park's boundary wall.

From the sand banks, John recalls there being a holding standing on the site of the billiard club rooms. This was known as

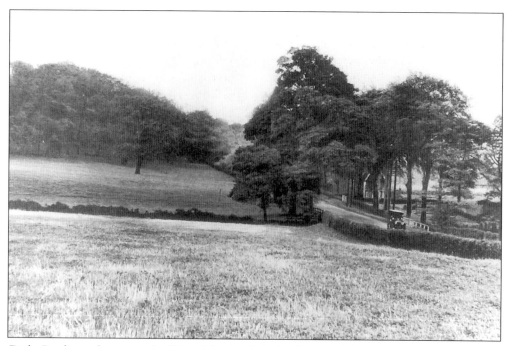

Derby Road near the present-day Priory Island with the Tottle Brook following the hedge line and going beneath the road where the white rails and car catch the eye. Thompson's Wood, Wollaton Park, is to the left in the background. (F.W. Parkes)

Garnett's Farm, and beside the usual farmhouse and cluster of outbuildings it was conspicuous for its fine Dutch barn.

Close by, a white-railed plank bridge over the Tottle Brook connected Bramcote Hills to the gypsy fields on which Beeston's Central Avenue has long since been built. Being one of the boys who harvested watercress from the Tottle Brook, John remembers the span of seven fields which linked the Parkside track with Bramcote Hills. The north-easterly section of these hills was clothed with bracken, briar, gorse, elderberry and broom, and provided nesting sites for yellowhammers, corn buntings, linnets and red polls, while pheasant, partridge and woodcock nested among the ground cover and, closer to the brook, an occasional mallard duck.

The sand track 'winding skyward' resembled a staircase to everyone using it, so not unnaturally perhaps the undulating upward or downward swing was known as the 'Devil's Steps', with perhaps the idea being that the Devil himself was waiting on the ridge between the last of the steps and the sky. Close to the Devil's Steps was a deep grassy bowl called Scouts Hollow and after an afternoon spent bird-nesting, I used to go there with my friends and sit drinking from a bottle of lemonade. Above Scouts Hollow and aside from The Devil's Steps was Snaky Woods, so called because a colony of adders or vipers (Britain's only poisonous species of snake) thrived in the bracken and gorse wilderness surrounding the stands of both pine and deciduous trees.

74

If one continued along the track towards the end of Noggins Lane he, or she, came to Blackberry Wood beyond which lay the fields of Model Farm then being worked by the Raynor family. The track descended to meet with a carter's track which connected the fields to Model Farm. Beyond the farm was the humpback bridge over the canal, alongside Jackson's Holding and the Clayholes Field. From here the walker could continue along Brickyards Lane (called Moor Lane today) and ramble on through Balloon Wood to the turnpike cottages on the main Nottingham to Ilkeston road.

John can still vividly recall the harvest time scene from the knoll above Snaky Woods. 'There were hay-carts being pulled by horses, the first grey Fordson tractor or two parked beside the hedgerows, row upon row of stooked oats, wheat or barley, and communal picnics on the edge of the most sunlit field.

But besides the harvesters, there was always the farm worker or gamekeeper walking the hedge sides with shotgun cocked and at the ready, for there were rabbits and hares in abundance. Many had been disturbed by the harvesting operations and were still about for those intent on getting a number to share around "for the pot". Then when it was dusk and the last of the haywains had been trundled down the lane to the farm, the tawny owls would begin hooting from the oaks and pines of Snaky Woods and two or three barn owls would quarter the fields, like great white moths, as they hunted for the mice and voles that came out to feed on the oat and wheat particles carpeting the stubble.'

CHAPTER 9
Changing Times

Wollaton Park gardeners with a hand-operated mowing machine and a word or two for the photographer. (F.W. Parkes)

Wollaton's royal guest in September 1906 was King Edward VII, who drove to the showground from Rufford and the 'Dukeries' estates. By 1912, perhaps with the forthcoming Royal Agricultural Show in mind, Mr Pilkington the estate steward had divided the parklands into the following categories: 741 acres of grazing land, woodland, heath, decoy ponds, formal gardens and a stable block. This included 374 acres let out to tenant farmers for grazing cattle or for hay; 236 acres were used for game rearing and grazing the Middletons' horses, cattle and deer herds. The woodlands took in a further 82 acres. The paddocks extending north-west from the stable block to the village were divided by low fencing and extended across what is now the car park area to the edge of Lodge Two drive.

Closest to the blacksmith's block and work yards was Middleton's Paddock and the hilltop rising north to meet the boundary wall at Hirst Avenue was traditionally the estate

steward's paddock, which by 1912 was known as Pilkington's Paddock. The slopes of this paddock, with the small but impressive stand of Wellingtonia pines, was also used as the foxhound cemetery. Harold Walton, in particular, remembered the gravestones gleaming in the morning light.

Lord and Lady Middleton were by this time using Wollaton Hall as summer holiday accommodation having moved into Birdsall Hall, Yorkshire, on a permanent basis. Freda Parkes and Mary Bell gave me colourful descriptions of the Middleton entourage arriving at Radford station, their coach, grooms and horse teams having travelled by rail to be followed by the formal coach-and-four cavalcade from Lenton Lodge and along Lime Avenue to their hilltop home. Before their arrival, a stable boy was ordered to drive the peacocks up the steps and the lawns of the formal entrance where the Hall's interior

was checked out by Mr McBain and Miss Gilbert several times in succession.

In 1914 The Royal Agricultural Show was staged at Wollaton, the Middletons being at the time patrons of The Royal Agricultural Society. The Show's distinguished guest was King George V, who was entertained at the Hall and stayed over; Revd Russell and his daughters were introduced to him. During these celebrations, the Russell family laid on a tea party in the Rectory grounds for all the children attending the village school.

The Middletons then planned their own memorable occasion at Wollaton Hall when they held their golden wedding anniversary celebrations there in 1919. Their relatives and the tenants of Middleton Hall, Warwickshire, were also invited and stayed over.

On 20 July 1922 the Wollaton parishioners mourned the passing of Revd

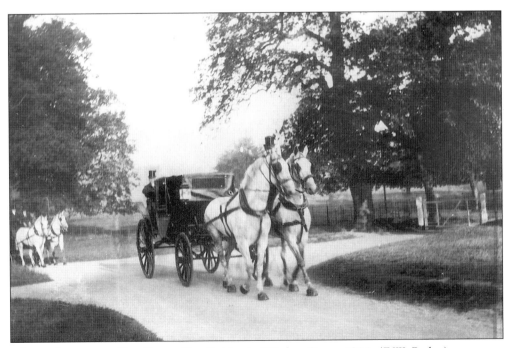

The coach conveying King George V, pulled by the Windsor Greys, 1914. (F.W. Parkes)

Russell. Then in 1924 Digby, the ninth Lord Middleton, who had owned the estate since 1877, died and only a matter of weeks later Her Ladyship also passed away. Everyone including the Russell sisters, who were by then residing in the south-west wing of the stable block, began asking what was to become of the estate and their own livelihoods.

The land agents who succeeded the steward Pilkington on his retirement were a partnership known as Messrs Render and Bell. While dealing with the mammoth task concerning the Middleton estates, they visited as many members of the tied accommodation staff as possible and eased their minds a little by reminding them that the recently deceased Digby Willoughby had a brother, Godfrey, who would probably take over the ownership of Wollaton. In the village, life continued, with the youthful Cyril Allen accompanying the pigs when they were goaded along what

today is known as Rectory Row by 'Skilly' Langsdale for the traditional pig sticking ceremony which took place in the Pig Yard situated next to the end cottage.

For several months the future of Wollaton Hall, park and village lay in the balance and during this time Cyril Allen and Lou Upton were allocated the task of visiting the Russell sisters in their stable block flat, collecting their huge basket of laundry and a gig, then catching Kruger the donkey who grazed Middleton's Paddock. After harnessing Kruger, the boys drove the gig to the cottage of Mrs Davies who lived in Wollaton Square. Mrs Davies gave Lou and Cyril tea and seedcake as soon as they arrived, took the washing to the back of the cottage, then produced a hamper filled with the previous week's washing already folded and ironed. Cyril and Lou returned to the stable block with Kruger always braying as he trotted down Church Hill. This resulted in one of the Lane family having the Lodge

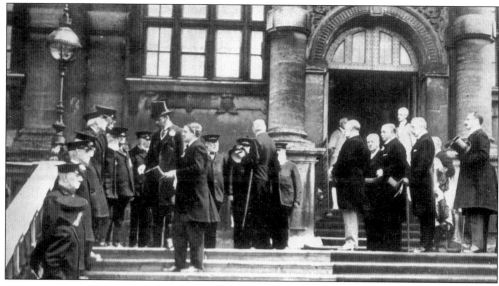

King George V meets members of the brass band and Wollaton dignitaries at Wollaton Hall's formal entrance, 1914. (C. Shaw)

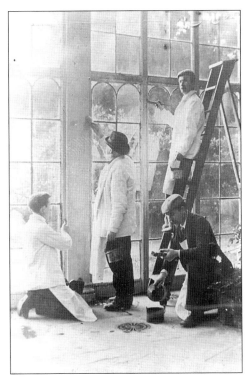

Painting the Camellia House during the times of change. Notice that the foreman is wearing a trilby or bowler and his staff cloth caps. (F.W. Parkes)

Mrs Davies lived facing the pump in Wollaton Square. (I. Hooley)

gate open before the gig reached the bottom of the hill so that the boys could drive through unhindered.

Lou Upton grinned when he admitted that he never really knew how he came to be the Russell sisters' Saturday morning laundry boy. And the same for Cyril Allen, although both lads thought the Russell sisters had arranged it with their respective parents. The hardest part of the 'damned morning', as Lou put it, was trying to catch Kruger in readiness for harnessing him to the gig. Kruger, he added, was buried in the old filter bed site close to the present day Lakeside Café.

After several months, the villagers learned that Godfrey Willoughby had decided to put the Wollaton estate on the market. This included, of course, the ancestral home and walled park. Most of the tenants had a notice to quit by post or delivered by hand along with a visit from John Bell, the Land Agent. Along with the solicitors based at Lincoln's Inn Fields, London, and Messrs Thurgood, Martin and Eve, the auctioneers similarly based in the capital, John Bell drew up a catalogue of sale with plots and lots allocated accordingly. The entire Middleton estate extended from the Lenton Lodge formal entrance to the banks of the River Erewash near Ilkeston and comprised some 4,164 acres. Withdrawn from the catalogue were the William Wright Institute and cricket

ground, the Russell School, the kitchen gardens and nurseries, and schools at Cossall and Trowell.

The auction took place on 23 and 24 March 1925 at the Mechanics Institute, Mansfield Road, Nottingham. Some tenants were able to buy the properties they were living in and before and after the auction there was much legislation and conferring taking place between such families as the Raynors of Model Farm and Moor Farm, the Bramleys of Broxtowe Hall, Dr T.B. Gilbart of Aspley Hall, the Banners of Bramcote Lane, Messrs G.E. and A.W. Taylor of Parkside Farm and the Ascoughs of Bridge Farm.

Quite a number of the 'top men' employed at Wollaton Colliery made bids for their previously rented houses on Colliery Row and others bought cottages, including the Old

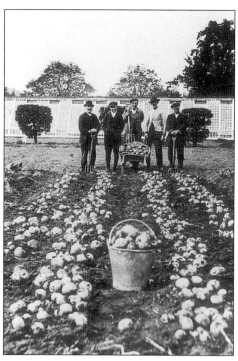

The potato harvest in the kitchen gardens and the gardeners known to Annie Goddard, Wollaton Park. (F.W. Parkes)

Brickyard Cottages and land scattered throughout the parish. Meanwhile, at Wollaton Hall the staff were issued with notices terminating their employment and the Russell sisters and other stable block tenants were served with notices to quit. The gate lodge tenants had also to leave and particularly upset was Annie Goddard, who then lived in Lodge One. Annie was a spinster who had always been a gate lodge tenant of the Middleton estates but was born in a gate lodge cottage on the Warwickshire estate. On some long forgotten date, she moved with her mother to Wollaton and her job was to cook meals and launder for the men employed in the kitchen gardens.

Because the walls of these gardens were hollow, the gardener had worked shifts to keep fires going all night so that the peaches, nectarines and other exotic fruits were kept free from the frost. The men had lived in small bothies situated along sections of the wall. These bothies contained a fireplace, bed space and table and chair space. Annie, being their provider, kept a back garden gate open so that the gardeners could collect their meals from her. Because she was a chronic asthmatic, whom Wilf Widdowson remembered as having nine cats, the Russell sisters took Annie's case to the local authorities and eventually she was allocated a flat in Smedley Close on the Bells Lane Estate. Sheila and Marjorie Russell then conferred directly with the land agent and were offered a cottage beside the redundant Brown's Sawmills. The cottage faced Raleigh Wood, had a grey-blue tiled roof and, in my time, was painted pale blue. There was no front garden, just a picket fence with a hedge of yellow privet alongside. It was dark, and damp. But the sisters lived there for quite a time.

A section of Whitemoor's farmyard. (F.W. Parkes)

The second auction involved the contents of Wollaton Hall. A brass band and refreshment marquee were positioned on the sidelines as most, if not all, of the Middletons' furniture went under the auctioneer's hammer. There was everything from stag heads to four poster beds, walnut cabinets, ottomans to teaspoons, the late Ida Page recalled.

The park, however, retained its deer herds, work horses and pigs. But the tenant farmers at that time, the Whitemoors, had to confine their cattle to the grazing of the Twenty Acre which extends north from the Hall to the park wall on Wollaton Road. The Whitemoors are remembered for having kept a particularly ferocious Friesian bull. As for the red deer, when the Russell sisters learned that the Wollaton Hall and parklands were about to be sold to the City of Nottingham Corporation as a public amenity, they advised the land agent that they had conferred with their Woburn Abbey cousins and arranged for a stag to be introduced from the Woburn herd to Wollaton. The stag was probably transported by rail to Radford station, but from there for the short distance to the park it was undoubtedly transferred into a horse drawn cattle truck. Both the Russell sisters and Billy Archer were present when the stag was released into the park. They agreed that its coat, or pelage, was a much deeper red than those of the original Wollaton deer which were brownish-grey; thus the Woburn stag could be differentiated from its herd rivals.

CHAPTER 10
Open to the Public

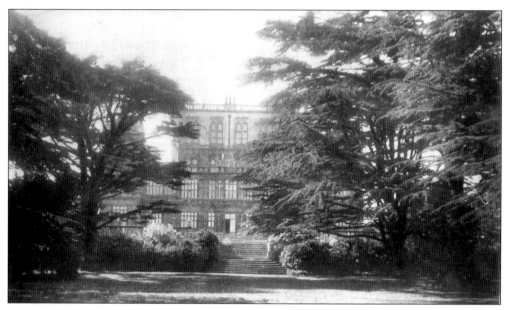

Wollaton Hall from the Cedars of Lebanon Lawn. (C. Shaw)

In May 1925 Wollaton Hall and park were sold to the City of Nottingham Corporation for the sum of £200,000, the agreement having been drawn up from September 1924. Although the Hall, stable block and gate lodges were empty, a few specialized staff were retained as gardeners and general estate workers. Gamekeeper Billy Archer was re-contracted, his prime task being rabbit and deer control. Pheasants and wintering woodcock still ranged through the woods and partridge 'coveys' occupied the open parklands. But game rearing as such had ceased.

Billy's sidekick Jesse Oliver was also kept on along with Bill Pacey the stockman, for work horses and pigs were still being maintained. Billy's young protégé Harold Walton, who was born at Parkside Farm literally just over the park wall, acquired a gamekeeper's position at Strelley Hall.

On 22 May 1926 the public were admitted into Wollaton Park. Many arrived by tram and the outer gates of Lenton Lodge were opened alongside a sign indicating the time at which the gates would close. A *Nottingham Evening Post* reporter was pre-

sent and no doubt saw, but made no mention of, Billy Archer patrolling the park on a white cob.

For Wilfred Widdowson the following winter was the last in which he drove horse and dray each dusk from Whitemoor's Farm to Deerbarn Wood, where he scattered many machine split swedes and mangles down for the deer. Groups of deer came sweeping across Arbour Hill when they saw the horse and dray approaching Deerbarn Wood. Wilfred told me that sometimes fifty stags were trooping behind him.

However, Arbour Hill and Deerbarn wood were designated to become part of a landscaped golf course, and soon after the public were admitted to the park, one-third of the acreage was closed to them and an old right of way extending from Hall Corner Spinney and across the slopes of Arbour Hill to

Beeston Lodge was overlaid with turf. The golf course was planned, designed and laid out by the Williamson brothers. The Tudoresque style golf pavilion placed within a stand of oaks was designed by T.C. Howitt. It cost £9,145. On 5 May 1927 the eighteen-hole course, divided by Lime Avenue and including the Family Plantation, was officially opened by a quartet of professional golfers who staged exhibition rounds. Men and women members played from Monday to Friday. Saturday, however, was a 'gentlemen only' day and until the mid-1960s no golf was played on Sunday.

Red deer stags during the autumn rut and golfers do not always mix, as the golfers found to their consternation. The hinds roamed the parklands searching for calcium-enriched acorns and beech mast, and the roaring stags followed the hinds while at the

The Bird Room, part of the Natural History Museum's collection at Wollaton Hall. (Local Studies Library)

same time attempting to ward off rival stags. The golfers discovered that if they disturbed a group of hinds the stag would make aggressive moves towards them as he would another stag. Consequently, a green-keeper carrying a stick was assigned to accompany the golfing parties during those bygone autumn days.

Meanwhile, the Russell sisters still visited the park, and in the autumn sought out Billy Archer or Jesse Oliver who took them over to see the Woburn stag, which by all accounts was a splendid bloodstock specimen and bred with the Wollaton hinds for five or six seasons.

As for Wollaton Hall, the Director of Museums, Professor T.W. Carr, backed by the Museums Committee, proposed it as a showcase for the Natural History Museum collection because the previous quarters at Carlton Road, Nottingham, were proving unsatisfactory. Thus the collection was removed to Wollaton and the Hall opened as a Natural History Museum on 28 October 1926. Until Easter 1927, the museum was open only on weekdays; then the hours increased to all day Saturday, and Sunday afternoons from 2 p.m. It was closed only on Good Friday and Christmas Day.

The Great Hall, Wollaton Hall, featuring the Mammal Gallery and the work of the museum's first taxidermist, Leonard Wilde. (Local Studies Library)

CHAPTER 11
A Housing Estate and More

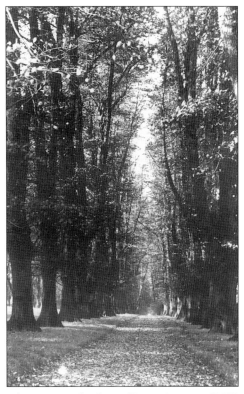

The mature splendour of Lime Avenue. (F.W. Parkes)

Frederick William Parkes, photographer and the first Superintendent of Wollaton Park employed by Nottingham Corporation. (Freda Parkes)

Wollaton Park's first official superintendent employed by the City of Nottingham Corporation was Frederick William Parkes, who had previously trained at Sandringham. For a time, the Parkes family lived in the Head Gardener's house in the kitchen gardens but, for some reason, the Corporation contracted these out to a firm of horticulturists and the Parkes then moved to a stable block flat facing the Ice House Plantation. I have recorded a full account of Frederick Parkes' life in another book, *Old Nottinghamshire Remembered*, along with the memories of his daughter Freda.

For them both it was heartbreaking to discover that the contractors had pulled down the Orangery, especially since a year or two later the Nottingham Corporation reassigned and took over the management of the kitchen gardens. But the Orangery or its like was never rebuilt. Meanwhile, all around the east and west side of the park, building was in progress. Dead Dog Wood and Lenton Wood were no longer standing and Lenton Lodge stood isolated from the rest of the much enclosed 'new Wollaton Park', reduced to 525 acres.

The park staff were instructed by the Clerk of Works where the new park boundaries were to be, then they set about fencing the boundary with double height chestnut paling in an attempt to keep the deer in until new high wrought-iron railings could be dug in.

As they worked the park's estate, workers learned that 'one thousand houses and bungalows to be sold or rented to council tenants' were to be built around the park, but in particular on the east side. Both Billy Archer and Jesse Oliver were quick to point out over their evening pints in the Admiral Rodney that the building land chosen by the Housing Committee was 'low-lying'. Therefore snow and frost lingered long in the hollows and fog, in October and November, had been known to enshroud the area for days. 'Why, all the tenants will be suffering from bronchitis and arthritis before they're retirement age,' Billy told Wilf Widdowson, who described to me the sad days in which firms of timber contractors moved in and set about felling many of the mature trees and uprooting the game coverts.

Beyond the new boundary fence, timber was being hauled onto wagons, foundations were dug and surveyors conferred with building contractors while walking with blueprints in their hands. Each midday as he walked to the Rose and Crown, Billy Archer passed through these scenes of environmental chaos and sometimes remonstrated with the gangs employed to lay the foundations of the 'new type' of houses that were shortly to be erected. One Clerk of Works named Noble explored the possibility of obtaining a pair of stag's antlers and Billy duly gave him 'a fine pair carrying twelve or thirteen points'. There was also a neat bullet hole in the forelock which displayed Billy's prowess with the shotgun or the old naval rifle he used.

Nor was the Clerk of Works slow to point out the path and grooves made by the deer as at night they attempted to venture along the fence to the acres of parkland they had known in the past, and Billy Archer rightly pointed out that it would be the generations of deer born after the boundary fences had been erected that would settle into their new environment.

It was around this time too, in the autumn, that the Woburn stag attempted to leap the new boundary fence and was impaled, much to the concern of the building gangs and the estate staff, including Jesse Oliver. A much saddened Billy Archer had to shoot the stag, then with his colleagues lift it off the fence. News concerning exceptionally fine red deer stags travels fast and Harold Walton, who was still employed on Squire Edge's estate at Strelley, free-wheeled his bicycle all the way down to Wollaton to look at the Woburn stag's antlers before they were handed to a taxidermist for mounting on a shield. Harold recalled that, even in his seventh or eighth year, the Woburn stag carried antlers longer in the beam and bearing a wider span than any other stag in the park. 'He was a sixteen or seventeen pointer and exceptional in every sense of the word.'

Middleton Boulevard in the early stages of development. Notice the remains of Wollaton Park in the background. (Local Studies Library)

Meanwhile, puzzled by the lack of bricks and lorry loads of pre-cast concrete slabs that were being delivered to the building sites, the estate workers learned from both the builders and reports in the local newspaper that Councillor William Crane envisaged the newly fashioned type of house in which the roofing trusses and walled frameworks were to take the form of steel girders. The Corporation, anxious to connect sections of the long proposed Nottingham ring road system, allocated a section of road beyond the 'new' Wollaton Park formal entrance to link Wollaton Road with Derby Road. With pavements, lime trees and grass verges either side and a grassed central reservation also planted with two lines of lime trees the road was called, not surprisingly, Middleton Boulevard.

Other reference to Wollaton, however, was not made when the roads and crescents were named on the estates either side of Middleton Boulevard, although local historian John Holland-Walker reminded the Planning and Housing Committees that a small medieval village called Sutton Passeys had thrived for a relatively short period somewhere in the vicinity of Harrow Road and Radford Bridge Road. And so it was decided to incorporate the name by way of recognizing and commemorating historical fact.

The Russell family deservedly shared the same distinction as The Middletons in that a bypass and connecting crescent were named after them. Fittingly, Russell Drive bypassed the rear entrance of the Rectory and Martin's Pond, both of which the family were closely associated.

Once the land either side of Wollaton Road was acquired by the local builders and developers, the road was widened from the canal bridge to the bypass and houses were built behind the park wall and the boundary hedge on the opposite side. The houses on Harrow Road overlooked Goode's Field and Gorsebed Wood, thus giving the residents interesting views of the park. West and south-west of the Hall, individual plots of land were sold off to private builders. These overlooked the park and golf course with the formal drive, Lime Avenue, creating a dividing line beyond. These land plots were each sold for around £3,000 and at some unrecorded date the park's boundary wall was lowered from Adam's Hill to Lenton Lodge at Hillside, although many fine trees still remain.

Early morning commuters from Derby Road and Lenton Abbey estate regularly saw pheasants crossing Derby Road as the birds explored what are now the University campus shrubberies. Some romantics called the stretch of Derby Road 'the green way into Nottingham'. Other green pockets left by the planners and builders were the spinneys, some comprising lime trees, others oak and pine. These were appropriately fenced with the exception of two, a spinney of Scots pines and another of oak and lime, the mature trees of which can be seen today in garden plots either side of Middleton Boulevard. The spinneys were encircled by roads with bungalows or houses on one side and called Fardon Green, Hawton Spinney and Orston Drive Spinney.

The cattle gateway at the side of Lenton Lodge was developed and used as a paved 'snicket' leading to and from the roads and crescents adjacent to Orston Drive.

At the junction of Middleton Boulevard and Wollaton Road, a long block of shops were built with accommodation above. New

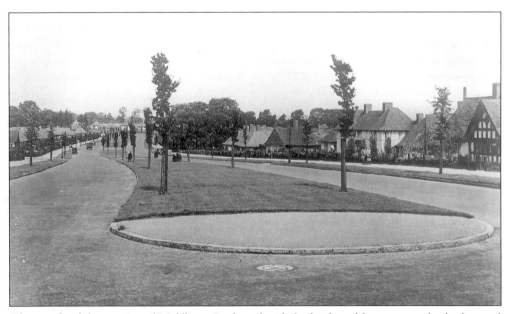

The completed first section of Middleton Boulevard with freely planted lime trees and a background spinney. Notice the different house styles on the right. (Local Studies Library)

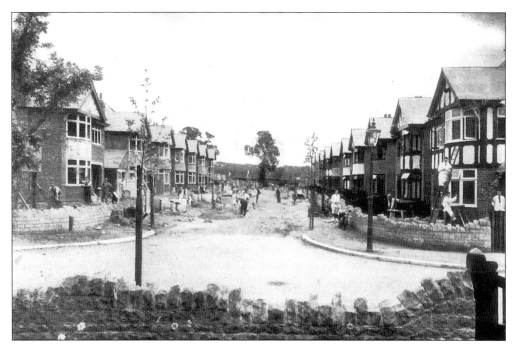

Building is nearing completion on Eton Grove, with a show house open by appointment, c. 1931. (C. Shaw)

detached houses were also built where the section of park boundary wall had been removed. The first phase ended at No. 211 Wollaton Road, and this address was at that time considered to have been the last Wollaton house included within the Nottingham City boundary. A few years later when building began again, the boundary was extended to include Eton Grove.

As far as the City of Nottingham Corporation was concerned, the costs involved in purchasing Wollaton Hall and park had been recouped and about one thousand families given the choice to begin again in pleasant new homes.

Although the entrance gates to Archer's Lodge had been removed along with the section of boundary wall, the lodge remained within a circle of trees and for some years, until 1936-37 at least, Billy Archer and his

wife continued to live there, within the freshly railed park boundary. An acquaintance who lived in one of the Wollaton Road houses and overlooking Archer's Lodge told me that the house itself was quite impressive and nothing like the lodge gate cottages further along Wollaton Road. Sometimes it was referred to as Archer's Farm. It certainly looked more like a big rambling farmhouse than a lodge. It was a lovely old place and would have fetched 'quite a good sum of money today', my acquaintance added as he recalled it.

Wollaton Village was still regarded as being in Nottinghamshire but for Billy Archer and Jesse Oliver, things were never to be the same again.

CHAPTER 12
The Thirties

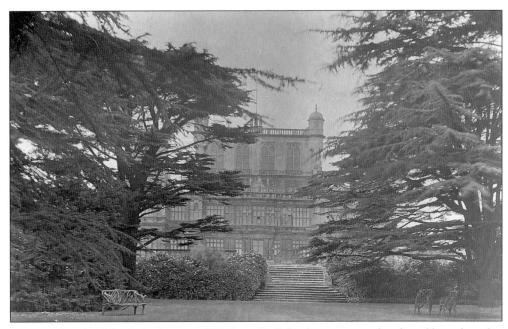

A postcard study of the Cedar Lawn and Wollaton Hall, by this time opened to the public with garden seats and rustic chairs provided. (F.W. Parkes)

Wollaton Park and Newstead Abbey were now managed by the Nottingham Estates Department. Because of the changing times throughout the village and park, the thirties were linked mainly to incidents experienced by both visitors and employees throughout the area.

Charlie Noble, the Clerk of Works' son, visited Wollaton Park on Boxing Day afternoon 1931. By this time the Corporation had stocked the lake with coarse fish and were allowing ten anglers to the lakeside each day. A wooden boathouse and single rowing boat were installed near the lake's outlet overlooking Thompson's Wood. The bank of The Dam was fenced and known as the Fishermen's Enclosure. The Duckride was also open to anglers. Charlie Noble described how he was spinning for pike with a pair of swans rooting their necks below the water surface and feeding about forty feet away, when one of the swans began tugging and

thrashing to the extent that Charlie realized it was in trouble. Eventually the swan remained still with the head submerged. When a keeper came to sell him a fishing ticket, Charlie pointed out the swan and the keeper took out the rowing boat. On reaching the swan's body, he discovered that a large pike had grabbed the swan's head while it was feeding underwater. In the pike's grip the swan had suffocated and the pike had choked to death, a bizarre situation but not totally unknown.

Lionel Baker from Cherry Orchard was a youth employed on the Wollaton Park staff at this time and he recalled the superintendent, 'Father' Parkes, announcing that a new stag, from the Duke of Portland's herd at Welbeck, north Nottinghamshire, was due to arrive within a matter of days. The stag's antlers for the purpose of transportation had been sawn off, which was not unusual for these times. Rather than allow the stag to leave the cattle truck and run out across the parklands, the men decided it would be best if it were stabled for at least a day, hopefully to gain a homing instinct to its new surroundings. When the stag was released, it was not seen in the park again. But the following day Billy Archer was told about an antler-less stag impaled on the fence bordering the New Aspley Gardens, situated alongside the equally new Western Boulevard between Chalfont Drive and Aspley Lane. Billy and Jesse took the horse, dray and shotgun and the unfortunate stag was despatched and released from its predicament.

It is not known whether fresh stock was introduced to the fallow deer herd at this time but the Victorian-Edwardian naturalist, Joseph Whittaker of Rainworth near Mansfield, contributed some of his stock and the late Major Chaworth Musters of Annesley Hall seemed to recall his grandfather sending one or two fallow deer to Wollaton, although there is no known Herd Book record relating to this.

Another stag incident involved the tenants of Lodge Two on Wollaton Road. One autumn night the family were kept awake by a stag herding hinds and consistently roaring beneath the nearby oaks. The hinds were feeding on acorns. Against their better judgement, a member of the family sent out their red setter which was later discovered dead. According to the tenants the setter had been gored by the stag. This is a possibility but, in the author's experience, it was probably a group of hinds that slashed the dog with their fore-hooves as they would an attacking wolf, and trampled over its body.

Away from the park and in the village community, the Russell sisters were keeping in touch with as many villagers as possible and attending to the villagers' needs while serving on several councils. They backed all the concerts held at the William Wright Institute and continued visiting the Russell School. As school governors, they also visited schools at Bilborough, Broxtowe and Basford, while retaining their combined interests in all matters to do with St Leonard's church.

Since the coming of the railways, the canal companies experienced an understandable decline in business and the Nottingham Canal Company was no exception. The last longboat came down the Wollaton Flight in the summer of 1936. From then on it became a paradise for the occasional bird-watcher, coarse angler and boys collecting frog spawn.

Adding little to the roadside landscape, the Wollaton Road-Triumph Road gasometer was built, it is thought, in the late twenties to the early thirties and, by 1933,

provided the unsightly background for photographs taken from Wollaton Road near Tretons Cottage. Bill hoardings also screened the Romany encampment field which is thought to have been forcibly abandoned by that time.

The Middleton Boulevard shops numbered a greengrocer's, chemist, post office and Cunnah's the newsagents. There may have been an off-licence in competition with the single shop way down Radford Bridge Road.

The changes in the village were comparatively few, although the people moving into the houses opposite Lodge Two on Wollaton Road and along by St Leonard's Drive and Tranby Gardens began complaining about the ceaseless cawing of rooks, which in

The angler's boathouse beside the Dam enclosure. (From the author's collection)

March and April nested in the oaks surrounding Lodge Two, and also in two sizeable ash trees situated on Wollaton Road. There were an estimated seventy or eighty nests in the tree branches. In an attempt to dissuade the rooks, Mr Parkes the Superintendent had the two ash trees felled but retained the oaks within the park wall. Consequently, the rooks nested there for the next twenty or so years, the felling of the ash trees having made little difference.

Although the deer herds were distanced now from the Radford streets, youths went into the park with dogs, not to poach, but to cause mischief. Their lurcher-type dogs were set on the deer. This resulted, then as in present times, in hinds and fallow does dying annually in the woods during the calving season, due to the young having become breached and the female therefore being unable to give birth. Billy Archer and his underkeepers were kept busy throughout, especially as rabbit control was still an essential part of their weekly routine.

While the parkland attracted mischief-makers, it also maintained its champions, usually gentlemen from the houses on Adams Hill or Rothesay Avenue off Derby Road. One such gentleman, who like many sought out and befriended Billy Archer, posed for a camera beside a swan pair and their five cygnets which were trooping out of the moat to the lake. Mr Fox who lived at Derby Road was given by Billy Archer a fine pair of red deer antlers which he had mounted on a shield. In the early 1980s, due to the changing times and comparative disinterest in such trophies, these were returned to the museum's collection at Wollaton Hall.

CHAPTER 13
Wollaton at War

A wartime barricade intended to block the tanks of the Wehrmacht, positioned on Derby Road between the Hillside Canal bridge and Lenton Lodge, 1942. (Local Studies Library)

In 1940 Billy Archer fêted a particular Wollaton Park stag and told his fellow drinkers in the Admiral Rodney tap room that it was obviously sired by the Woburn stag, and that the park wouldn't see its like in antler width and body size for some years. And he was right. The next outsize stag dominated the autumn rutting seasons from 1964 to 1967. An agreement with the golf course committee resulted in the red deer being reduced to eighty head with the breeding or 'master' stags numbering three in the interests of public (and golfers') safety.

But the basic discussions, the basic fears, understandably revolved around the night-time bombings that concerned just about every British subject in the Second World War. By this time, the No. 39 trolleybus route connected the Nottingham city centre to the terminus at the Middleton Boulevard shops.

Because she was daily attending Miller's Business College, Freda Parkes used the route, then walked the three-quarters of a mile or so along Wollaton Road to the Lodge One gates.

The bombings began in October 1940 and Freda recalls hearing the air-raid sirens just as she dropped off the bus at Middleton Boulevard. She ran most of the way home, heard the bombs, and saw in the direction of the Chilwell Ordnance Depot the sky as blue as it was on a summer's day. Freda had a key to the Lodge One gates and just as she locked them behind her, she experienced the ground quaking at her feet as you would if you were experiencing an earth tremor. Fortunately Lodge One was still occupied and Freda stayed with the family until the bombing raid ceased. Then the husband of the new lodge gate couple walked her across the darkened parklands to the Parkes' stable block flat.

Meanwhile, in the village, residents were allegedly taking sides over an issue in which the Special Constable carried out his duties to the letter by reporting a family who, for some forgotten reason, refused to put up black-out curtains. Like all large country estates, Wollaton Park was requisitioned by the War Department in the sense that the paddocks were ploughed and used for growing crops. Because of the free-roaming deer and still numerous rabbits and hares, pole and wire barriers some six or seven feet in height had to be erected around each area. The field extending between the Gorsebed and the houses on Harrow Road was similarly fenced and used for the cultivation of flax which, apparently, was used in the manufacturing of parachute ropes. Both lodge gateways on Wollaton Road were then closed to the public as the army moved in, Nissen huts were erected and the area from the lodge gates to the foot of the Hall's north slope was transformed into a prisoner-of-war camp.

As a boy under school age, to whom the fears of war were played down considerably, I was first taken into Wollaton Park by the kindly aunt who owned the house in which we lived on Chalfont Drive. It was late afternoon and she walked me up Digby Avenue just to see the deer, my first glimpse of hinds couched in the long grass or standing beneath the shade of the trees. On my next visit, with my father, I experienced the freshness of autumn morning as on deserted Digby Avenue we collected acorns and walnuts while watching the pheasants and red squirrels. The first group of fallow deer my father pointed out to me were standing in a corner of the flax field and the Gorsebed with the flax harvest so thick and high, it almost covered the deer; but they were conspicuous as they turned, by their swinging black and white tails.

At the Middleton Boulevard end of Wollaton Road, I recall there being a barrier made of concrete which allowed one car at a time to pass through. On either side cylindrical concrete blocks had been piled. These were intended to be hauled or rolled into the gap, thus sealing off the canal bridge and Western Boulevard if the dreaded tanks of the Wehrmacht came along the ring road during an invasion. The No. 39 trolley bus drivers could just about ease their vehicles through this gap, my father explained, while pointing out that everywhere throughout the parishes of Wollaton and Aspley, from Balloon Wood to Shepherd's Wood, similar devices complete with ack-ack guns manned by Home Guard units had been set up in readiness for an invasion or localized attack. Landmarks such as the Player's Bonded warehouse on Wollaton Road were painted black

in an attempt to foil the Luftwaffe pilots and prevent them bombing the nearby railway.

I remember one night awaking in the arms of my father and finding myself wrapped in a blanket and being carried down the garden path to the Anderson shelter. Neighbours were filing in front of my family and behind. Above was a droning sound to which I failed to connect until my father pointed to the starlit sky and the dark bulks of Luftwaffe aircraft seemingly suspended overhead.

Two attempts to bomb the railway near Woodyard Lane resulted in both bombs creating craters in the nearby fields. One Sunday morning my father took me to see the hollowed and blackened ground between the railway and the canal, on which the houses at the top end of Charlbury Road have since been built. Both the Heaps family, who lived in the isolated farmhouse beside the canal bridge, and the Russell sisters, by then living in the woodyard foreman's cottage, would have experienced the ground-shuddering effects and no doubt the clattering and perhaps displacement of plates previously displayed on the Welsh dresser.

The services at St Leonard's church were relatively well attended throughout the war, but on my Sunday morning walks to the village with my father or sister Betty, there seemed to be no one on the roads as we walked steadily from the Middleton Boulevard shops and along Wollaton Road by the inner-walled houses and the park. Save for the cawing of rooks as we neared Lodge Two, everywhere seemed uncannily silent often until we were halfway up Church Hill, when the steady but staccato hoof-beats of horses and ponies announced the arrival of the Sunday morning equestrian class filing through the village from St Leonard's Riding School.

The War Department's Wollaton

During the war, Wollaton Hall gardens and parklands served as the temporary homes and workplaces of a surprisingly large number of people. They were a motley crew, by all accounts.

Into the Hall moved the caretaker Jackson, with his wife and family, due to their having been bombed out of their home in Nottingham. The Jacksons resided at the Hall as caretakers in what are still known today as Jackson's Quarters, for the next ten or twelve years.

Certain army officer units were also quartered in the Hall and two or three mornings each week the pupils of the Radford Boulevard School were escorted along Digby Avenue and into the servants' kitchen for their normal lessons, a session or two of which included natural history. One long-term resident of Denman Street recalled there being a stuffed hippopotamus in the corridor, although the children were not told that Wollaton's first taxidermist, Leonard Wilde, was quietly and skilfully working in a room nearby.

When next my father took me to Wollaton Park, two sets of contrasting images emerged. The first concerned the splendour of the mounted stag heads arranged along a west wing wall of the museum's Cockburn Mammal Room. The second revolved around the high and unsightly fence of rusted barbed wire that extended the length of the hall slope between Lodge Gate Two drive and Albany Avenue. Beyond the wire between the mass of Nissen huts, men in black track suits, with POW stitched clearly on the back, played football. At all four corners of the POW camp stood a guard unit. In later years, I was told that the prisoners embarked on cross-

country runs with their instructors and were also given such tasks as tree clearance and road surface maintenance to keep them occupied. The sluice and outlet on the north side of Martin's Pond was designed and placed by the German and Italian prisoners of war. And each weekday morning they jogged along the park avenues.

Billy Archer unfortunately reached retirement age at around this time, along with Jesse Oliver. Once retired, old age quickly overtook the once so active Billy, who died around 1943-44 in an old people's home at Breaston in Derbyshire. He was succeeded in his work by Jack Belton and about the last of the grey bearded crew to remain working at the park was stockman Bill Pacey, who lived in one of the lodges on Beeston Lane.

Wilfred Widdowson with his wife and son moved into the Head Gardener's Cottage off Wollaton Road. The park's estate workers usually finished their week around noon on a Saturday and Wilfred told me that, 'You could bolt the green gate to my lodge

then and merge in with all the foliage and think of yourself as having been forgotten because, other than my wife and son, I never saw another soul until first thing Monday morning. It was lovely enjoying your breakfast and tea on the lawn surrounded by trees, shrubs and flowers, and having a family or two of red squirrels looking in on you at the same time.'

When Wilfred left the Gardener's Cottage each morning, he not only saw the prisoners-of-war being drilled but also the Land Army girls going about their tasks, which usually involved cleaning out the poultry and work horses. At Wollaton, according to Wilfred, women never actually worked on the land except during harvest time, the one exception being 'a big-bosomed lass in a green jersey and fawn knee breeches, who actually spread manure across the fields with only a bucket and rake and excelled at other jobs that the War Office officials considered well beyond the physical capabilities of the average land-working woman.'

Bill Pacey's cottage on Beeston Lane. (From the author's collection)

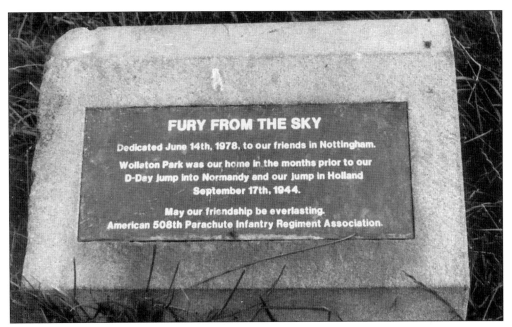

A plaque, 'Fury From The Sky', commemorating the American 508th Parachute Infantry's bond with Wollaton Park in 1944. (Local Studies Library)

On Saturday 31 July 1943 and the Bank Holiday Sunday and Monday following, Wollaton Park hosted 'The Greatest Wartime Show in the Country'. This was an agricultural, horticultural, cattle and horse show, organized by Mr Jack Sail, president of the Midland and District Pony Riding Association. The proceeds from the event went directly to the Nottinghamshire Services and Prisoners-of-War Comforts Fund. The programme, which cost sixpence, informed its buyer that 'over 2,000 of our boys who are in enemy hands from this County are assisted by the Fund.' The show was opened by the Lord Mayor of Nottingham, Alderman E.A. Braddock, J.P. and the Fund's vice-chairman, His Grace the Duke of Portland. Throughout the weekend, arena events were staged until 8.30 each evening; the last hour was given over to community singing and dancing followed by the

National Anthem. I am reminded of the first sheep dog trials I watched here on the Bank Holiday Monday, when I was taken by my father at the tender age of five.

In 1944 the paratroopers of the 508th Regiment of the 82nd Airborne Division, US Army, arrived and were billeted at Wollaton Park. The cavalcade of lorries transporting these 2,000 men on 10 March must have appeared nothing short of impressive. Each member of the regiment had been allocated a booklet entitled *A Short Guide to Great Britain*. On their days or hours off, they pleasantly invaded Nottingham city centre and such pubs as the Hand and Heart on Derby Road or Yates's Wine Lodge. The Jolly Higglers on Ilkeston Road became a favourite but Wollaton's own Admiral Rodney was seldom visited, although 'the Yanks', as they were known, did find their way to the

Wilfred Widdowson with tractor and trailer. (T. Widdowson)

Cocked Hat on relatively distant Broxtowe Lane, and the Beacon on Aspley Lane.

On seeing the red deer herd, three parachutists shot and mortally wounded two hinds, resulting in the US Army imposing fines on the culprits following the complaints made by the Nottingham Estates Committee. The resulting venison, however, was shared among the occupants of several billets. Despite this isolated incident, the paratroopers were well-received throughout the region before they played a vital role in the Normandy Landings. A week before this historic event they were confined to camp, split into temporary divisions and trucked out to various local airfields.

Wilfred Widdowson told me that 2,056 paratroopers of the 82nd Airborne Division were involved in the Normandy Landings, of whom 900 or so returned to Nottingham for a re-formation in Holland at Nijmegen. The rest of the regiment were wounded and quartered elsewhere and 307 were listed as killed on the battlefield.

In Wollaton Park, during wartime, one sad fatality involved a little girl who was excitedly running along the lake path just ahead of her parents when she saw, but being so young failed to recognize, a live hand grenade lying on the path and pulled out the detonating pin. The inquest, understandably, blamed whichever billeted division exercised mock battlefield manoeuvres

around the wood and lake on quiet weekdays when the park was seldom, if ever, visited by the public. The division's lack of vigilance was clearly outlined and such manoeuvres ceased thereafter.

Wartime Self-Sufficiency

Quite a few Wollaton village families acquired food beyond their rations by taking regularly to the fields and collecting mushrooms, blue buttons and all such seasonal fare, as well as snaring rabbits. One poor widow bringing up a young family regularly answered the night-time knock on the door and found each time a brace of pheasants hanging from a nail above the porch, although she claimed to never once having glimpsed her generous benefactor.

The Tottle Brook watercress beds along the narrow vale below Bramcote Hills were visited with surprising regularity and potatoes, swedes and cabbages were taken from the surrounding fields overnight. One man, who lived in a cottage set back from the main road but whom I have chosen not to name, scoured the canal side reed beds for the eggs of moorhen and mallard and, each April, raided the nest of the swan pair in the reed beds of Martin's Pond.

The mute swan pen lays one egg every other day and the mute swan pair usually completed their clutch with seven. Grinning, he gave me a colourful account of fending off the hissing and defensive swans while depositing each egg carefully into a bucket in readiness for the home-made 'swan egg omelettes' he would be sampling in the days to come.

CHAPTER 14

Just After the War

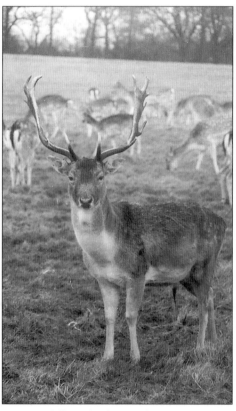

Mature fallow buck, Wollaton Park. (P. Crowther)

School Visitors

As an unwilling pupil of the Whitemoor Infants' School, Basford, I learned one day along with the rest of the class that we would be having visitors. Important people were coming – school governors. Therefore, we were expected to attend school the next day looking neat and tidy and remain that way. We must also be on our best behaviour, Miss Jones our Welsh teacher informed us.

They came late in the afternoon, about 3.30. The door of our classroom was opened by our darkly suited, bespectacled headmaster, who stood aside to admit the three or four silver-haired women. Two of them glanced at the blackboard and began talking to Miss Jones without hardly sparing us a glance. But the next two smiled openly and faced us while venturing 'Good afternoon, boys and girls' to which we answered collectively and in long drawn out monotone, 'Good afternoon, Miss.'

By looking in later years through old photographs, I realize that had formal

introductions been permitted, these two ladies would have been introduced to us as Misses Sheila and Marjorie Russell. I was much taken by their smart attire, blue two-pieces or overcoats, I can't remember exactly, although I dwelt a little on the fact that the blue they were wearing matched the blue of their warm and kindly eyes. The hair of each sister was thick, silvery white and brushed back to the collar. Their Edwardian hats differed in shape and style yet suited them perfectly.

At times they snatched a word or two with Miss Jones or the headmaster, glanced at the blackboard or scanned the attendance register briefly, but only for seconds because they were there to see us, the children, and in a most charming and gentle manner both sisters made us aware of this. That they were school governors may have meant something to them. But that they were seeing and concerned about the welfare of all children meant more. When they turned to leave, I noticed how straight their backs were as they moved with a quiet, dignified grace. Mr Jones opened the classroom door for the four ladies and the Russell sisters allowed their peers out first, then turning again and smiling bid us, 'Good afternoon boys and girls. Have a safe journey home,' and left as we drawled out our collective reply.

It was around this time, the end of the war, that Sheila and Marjorie Russell decided to move to Forge Cottage, the then recently vacated blacksmith's cottage on the corner of Bilborough Road and the narrow lane leading down to the vale settlement of St Martin's.

'They could still see Wollaton Hall on the opposite ridge across the fields and this aided their decision to move into Forge Cottage as soon as possible,' the late Ida Page informed me.

Wildlife Abounding

One Sunday morning when my father and I were walking along Woodyard Lane, he swung me suddenly onto his shoulder and pointed out my 'first' rabbit racing over a corner field and into Harrison's Plantation. Because so many local men were serving in the Forces, rabbit control decreased and both rabbits and hares increased noticeably.

Jack Belton walked with shotgun, nets and ferrets across Wollaton Park, but the allotment holders with plots adjacent to Martin's Pond and Raleigh Sports Ground had really to encourage the few elderly men who were relatively self-sufficient to set snares in those areas. Sparrowhawks, kestrels and owls had always been controlled by gamekeepers because they took pheasant chicks but during wartime at least, one pair of sparrowhawks nested in the Wollaton Park Woods and occasionally Harrison's Plantation where woodcock and pheasant were breeding. That barn owls continued to hunt undisturbed became apparent when, after an investigative flight in the summer of 1945, one entered an open window of Wollaton Hall, where I think that I am right in saying it was eventually netted and released. This was probably one of the pair that bred in the derelict smithy and stables of Woodyard Lane.

Residents of the bungalow estates either side of Middleton Boulevard were surprised to learn that tawny owls still roosted in the road and rooftop segregated spinneys, although owls would have hunted in and around Wollaton Park. During a spell of exceptionally hot dry weather, one young tawny owl attempted to bathe in a water butt situated beside a Hawton Spinney bungalow but due to its feathers becoming heavily waterlogged, the bird subsequently drowned.

On still, frosty nights tawny owls could be heard fluting outside Wollaton Park as well as inside, particularly from the spinney on the corner of Orston Drive, the limes of Derby Road near St Mary's church, Hawton Spinney and the well-wooded little spinney situated beside the canal and opposite the Middleton Boulevard shops.

It was during the aforementioned dry summer that the fallow buck herd left Wollaton Park, possibly by leaping a garden fence on Harrow Road, and roamed in a wild state through the Martin's Pond reed beds, the adjacent allotments where they plundered the crops and flowers and onto the canal path and embankments. Mrs Wood, a resident of Charlbury Road and whose garden backed onto the canal, related how one morning she was hanging washing out on the line when she realized that a group of fallow bucks were standing furtively yet conspicuously watching her. The bucks however kept to the canal, at least as far as Deepdale and Raynor's Farm where they were relocated, feeding across the fields then rising disturbed from the bracken beds of Bramcote Hills. A story associated with these fallow bucks, which I have always had difficulty believing, revolves around a man who was supposedly out blackberrying along the canalside hedgerow when a buck leapt the hedge from the opposite side, crashed onto the man and broke his nose. Furthermore, the injured party is supposed to have attempted to claim compensation from the Corporation of Nottingham Estates Department. At the onset of the autumn rut, the fallow buck herd returned to Wollaton Park and repairs were carried out along the periphery fences which kept the bucks in throughout the summers that followed.

Compensation due to damage caused by deer was paid out with surprising regularity to the allotment holders of Sutton Passeys Crescent. The allotments were situated where the Glen Bott School now stands and the red deer in particular leapt over or negotiated ways between the chestnut palings to feed on the cabbages and lettuces. A Hawton Spinney resident exercising his spaniel along Sutton Passeys Crescent one moonlit night startled 'a magnificent stag which stood braced and looking at me with lettuce leaves dangling from his jaw line.'

My first sighting of a kestrel hovering in silhouette against a blood red sunset occurred on the evening of 15 May 1949. The kestrel was hunting over the tract of derelict land on which the Beechdale Baths have since been built. Beyond the kestrel, Wollaton Hall was etched into black, alongside which rose the trees and woods of the park where I had little doubt a pair were rearing a brood.

When Jack Linthwaite Patrolled

To maintain a degree of order within the confines of Wollaton Park, the Estates Committee decided to introduce a patrolman wearing a police constable's uniform with a peaked cap. He looked authoritative. He also patrolled at the weekends, particularly Sunday afternoons when the public still arrived by double-decker bus and entered the park either by Lime Avenue or Digby Avenue. There were very few visitors during the winter but the patrolman was still required to patrol and at dusk cycle down the avenues, turn back the people who were coming in and, when they were finally out, lock the gates.

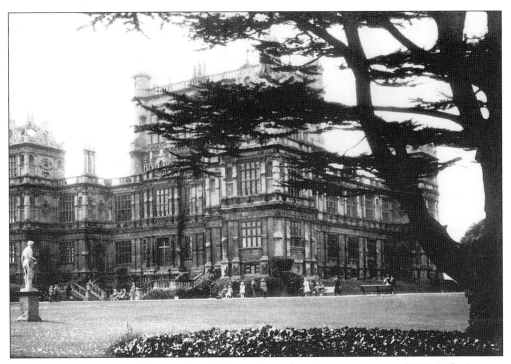

The formal gardens of Wollaton Hall with their early intake of summer visitors. (F.W. Parkes)

Jack Linthwaite was the first of these police-uniformed patrolmen. He resided in a stable block flat. During the summer he announced the closing time hour by ringing a hand bell from the ornamental gardens then shouting through a loud hailer. Like most Wollaton Park employees, Jack had a tale to tell about the deer and in particular the sixteen-pointer stag that was roaring and herding hinds on Digby Avenue as Jack free-wheeled down in the autumn darkness to lock the gates. Jack thought it was his bicycle light that for some reason provoked the stag into trotting alongside, roaring and attempting to attack him. On reaching the Digby Avenue gate Jack locked it, cycled around Sutton Passeys Crescent and re-entered the park via Lime Avenue up which he rode to reach his stable block flat.

A similar incident occurred in 1982 on Digby Avenue where many red deer fed on the acorns and beechmast. By all accounts, gangs of local youths visited Wollaton Park purposely to provoke Jack Linthwaite. They climbed trees, stampeded through the woods, chased the deer herds, yet unlike today they did not commit acts of vandalism in the sense of destroying and smashing items of antiquity that have been standing for decades. Jack Linthwaite also had police and magistrate backing. Consequently, several youths attended court, were charged with chasing the Wollaton deer and fined accordingly.

My father and I encountered the type of youth Jack Linthwaite sometimes had to deal with one autumn Sunday afternoon. The red deer were feeding on acorns in Hall Corner Spinney and tolerated the four or five youths strolling up Lime Avenue until the youths

began barking like dogs and howling like wolves. Many hinds, calves and the three adult stags turned and trotted towards Deerbarn Wood, leaving a matriarch hind to sample the acorns alone. The youths continued howling as they walked towards Wollaton Hall and I remember Dad referring to them as 'the idiot brigade'. In retrospect, they were probably regular troublemakers so far as Jack Linthwaite was concerned.

New Sounds Hereabouts

Before the post-war building programmes gradually included Wollaton in the city boundary, matters went on as usual with the old village families keeping in touch. The pig-sticking tradition was banished, though, along with the horse and cart. New forms of transport, notably flat-backed lorries and slightly fewer cars than before, were to be seen along the roads and Fordson tractors trundled along the lanes.

Those many Wollaton residents who had previously walked to the tram stops on St Peter Street, Radford, or Hillside and Faraday Road, Lenton, welcomed the arrival of a regular bus service administered by the Midland General Company. The cream and blue-liveried double-deckers passed through Wollaton via Russell Drive en route to Trowell and Ilkeston.

Many of the miners at the colliery had ceased walking in gangs and were cycling to work or, in a few exceptional cases, arriving by motor-cycle. Mr Frederick Hallows, who upon Frederick William Parkes' retirement succeeded him as Superintendent of Wollaton Park, drove to his offices at Wollaton and Newstead by car, whereas the rest of the staff cycled to their various yards and propagation sheds.

Lionel Baker, having returned to his employment at Wollaton Park after serving abroad with the Royal Air Force, had only a short distance to cycle because he was temporarily housed at Beeston Lodge on Derby

The gardens, facing west, during Frederick Hallow's time. (From the author's collection)

Road after marrying Lucy Hardy of Radford Woodhouse. From there the couple moved eventually to Woodside Road, Lenton Abbey. The woodsman, Charlie Todd, and his wife moved into Lodge Two. When he wasn't felling trees with his legendary axe, Charlie erected fences, cleared drains and was teamed with Harold Walton who had been demobbed from Army service. Harold was employed as deerkeeper and gamekeeper as well as estate worker, and he and Charlie Todd worked together exceptionally well. Charlie is remembered for having kept the blade of his axe clothed by a sack whenever it wasn't in use and the last time I saw him enjoying a pint of bitter in the Priory when he was into his nineties, Charlie still carried the broadest, squarest shoulders I have ever seen on any man.

A short distance from Lodge Two lived George Carrington and his wife, in the old police house, I believe, almost opposite Wollaton House, his employer's residence. Wollaton House was then owned by the local newspaper magnate Mr Thomas Forman Hardy, to whom George served as gardener and general *fac totum*. George particularly loved to be under the beech trees there looking over the snowdrops and early crocuses, while watching the sun rise across the parklands and plunging Wollaton Hall into deep silhouette.

The Russells' Bequest

When they had settled into Forge Cottage, the Russell sisters continued their community work and Sheila successfully negotiated with local councillors to acquire the lovely old farmhouse situated in the vale of St Martin's and which is still known as The Sheila Russell Centre.

A Glimpse of the Canal

It is time now to explore beyond Colliery Row and Bridge Farm while pausing to look down at the canal, still deep here as it curves around the ash and willow plantation with its singular bungalow, creating an atmosphere of seclusion.

For a further hundred yards or so the canal bank opposite the towpath was screened by ash, willow and poplar trees, then Davidson's Field swept down to the water's edge and I remember one huge ash tree in particular casting its wide-spreading reflection over the water surface. Horses used by the St Leonard's Riding School grazed this field and a pair of Emden Touloise geese – the gander brown and goose white – used to preen in one of the several sandy bays. To the left were the fields of what is now Deepdale Drive and the Fernwood School complex, at that time grazed by cattle but with building about to start in the 1950s.

One recollection I have of the sandy bays is that of leaving my sister's new house on Deepdale Drive and cutting the field corner by the top of Goodwood Road, bypassing two small ponds and hawthorn thickets to the right, then going onto the canal towpath via the hedge gap. The sky was the deepest red I had seen and was reflected in the mirrored surface of the canal. The reeds were etched black as was the cob swan anchored and preening in a bay; the top of his lowered head just skimming the water as he preened his underparts and caused the faintest ripple to break the spell of petrifaction.

The railway passed almost alongside the canal at the end of Davidson's Field then to the left more thickets and coverts of broken land harboured rabbits and woodcock around the pools known locally as 'Frog Hollows'. On the opposite side of the canal

A nesting pair of swans on the canal with what are now the rear gardens of Glover Avenue in the background. (From the author's collection)

a long plantation screened a private holding and kennels where Alsatians were based. This was a straight stretch of the waterway where swallows and house martins hawked for insects throughout the summer and also where I watched my first kingfisher.

The Tottle Brook rattled through a pipe below the canal here, and wound through the willow thickets towards what is now the lower end of Wollaton Vale. Ahead was an accommodation bridge known as Raynor's Bridge after the family, two brothers and one sister, who lived in and worked the farm situated beside the bridge arch to the left. Model Farm, as their holding was called, was locally typical in that it grazed cattle. Mary Raynor crossed the bridge with a pony-drawn float each morning and delivered milk to residents on the nearby Firbeck estate which

had been built on land adjacent to Trowell Road, backing onto Balloon Wood. Locally she became known as 'Mary from the dairy'.

Beyond Raynor's Bridge the canal curved by the reeded wharves of the old Middleton brickyard. Here the Jackson family ran a smallholding and gradually built up a coal merchant's business. This was situated on the site now occupied by the houses and flats of the North British Housing Association. Close by, in the hedgerow beside the towpath, stood the canal lengthman's tool and equipment hut known as Grangewood Cabin. Two barges were moored in the wharf. These were used for puddling clay when leaks appeared in the canal bed, the clay having been bought by the canal company from the owners of the brickyard site. After the war the wharf became reeded, a pair of swans and

moorhens nested there, but the abandoned barges have since been buried beneath the topsoil of what is now Grangewood Road. On the evening I saw the swan etched into the sunset, I walked back to Chalfont Drive via the canal towpath and came out at the bridge on Woodyard Lane. The towpath however led all the way down to Lenton and the Nottingham Canal. So given the time, one could walk from the canal's termination point at Langley Mill to Nottingham and the River Trent along the towpath and quite possibly not see another person throughout the entire journey.

With the end of the war Lawrence or 'Loll' Baker of Cherry Orchard on the Aspley Hall estate married and settled in New Zealand. In the early eighties he revisited Britain and his brother Lionel brought him to my home where 'Loll' enthusiastically recollected his days spent working along the Wollaton canal.

The headquarters and maintenance storage sheds stood on the canal bank opposite Peartree Cottage on Radford Bridge. The canal bridge, now known as Crown Island, was in Loll's time hump-backed and narrow to the extent of it only allowing one car over at a time. Opposite the Crown Hotel, in those years occupied by a blacksmith and farrier's business, three cottages backed onto the canal and one resident, Mrs Voce, is remembered for keeping a somewhat ragged donkey in a shed.

The Baggerley family lived in Peartree Cottage which, along with the works buildings, was owned by the London & North Eastern Railway company. Mr Baggerley was in charge of canal maintenance operations and also employed as a railway inspector. Bill Mitchell was his foreman, in charge of the dredging teams. The outbuildings consisting of a barge repair store and joiners', blacksmiths', stonemasons' and general carpenters'

The canal bend beside Glover Avenue corresponded with the waterside boundary and the curve at the beginning of the comparatively recent Moorsholme Drive. (From the author's collection)

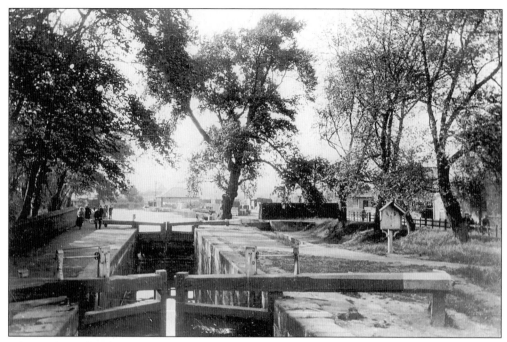

The canal in Loll Baker's time, looking from the Crown Island bridge with Radford Bridge Road on the right. (Local Studies Library)

shops. Fred Sly took on the role of canal maintenance foreman, his duties extending from Wollaton Colliery to Swansea Bridge, Trowell. Each day the foremen cycled along the canal towpath checking on their work teams and moving labour as and when it was thought necessary.

The Puddling Process

Puddling clay was loaded onto the barges from the Middletons' brickwork site known locally as Clayholes field. When a leak was detected in the canal bed, the maintenance barge was manned there and the puddlin' clay poured into the leakage cracks. A leak, incidentally, was detected by a swirl of water appearing consistently on the surface. When the maintenance crew reached the leak and the puddling clay was poured in, the men wearing waders had then to step overboard, backs to the barge but holding onto it with one hand, then stamp the clay down into the crack with their booted feet.

In the summer Loll and the lengthmen mowed the grass along the canal towpath, raked it up as piles of hay, then the foreman negotiated with and sold it to the nearest farming family. Raynor's Farm at Grangewood had a considerable stack of hay raked from the canal towpath in this way.

The hedgerows had also to be cut and in the autumn and winter the towpath was re-laid with ash which the barges brought down from the colliery yards. The men had also to rake from the canal surface lengths and streamers of encroaching water weed. Loll and his workmates created pegs for the local

anglers and Percy Ping, another mainte-nance foreman, also sold fishing tickets.

One of Loll's fondest recollections is that of leaning on a farm gate eating his 'snap', consisting usually of bread and cheese, while listening to the corncrakes calling across the fields of Bramcote, Cossall and Trowell Moor. Now practically extinct throughout the English Midlands, the corn-crakes fascinated Loll, who delighted in watching them stepping furtively ahead of the horse hoe. Occasionally, he found a nest among the sugar beet. Built of dried grasses, the nest usually contained a clutch of eight to twelve eggs.

Moorhens were as common as the barn-yard's brown rats and hedge-bank rabbits. The maintenance men often found their reedy, deeply cupped nests containing nine or ten buffish eggs with liver brown spots or blotches. Loll compared the long drawn-out whistles of the moorhen chicks to the chur-ring songs of the cock sedge warblers, the more melodious notes of the reed warbler and the repetitive but gladdening calls of the cuckoo.

Frog spawn, toad spawn and tadpoles were everyday sights in the spring and Loll remem-bered the 'scores of frogs, croaking, and masses of spawn which I have never since seen the like throughout the small pools and reeded runnels of the Frog Hollows'.

Occasionally, Loll or someone flushed a fox from the sloping woods leading up to Blackbird Lane (which is now Coventry Lane).

Percy Ping

On my evening rambles along the canal I would pass, as I approached Raynor's Bridge, a derelict railway carriage on the opposite bank. Loll told me that a decade earlier and long before that the canal lengthman Percy Ping and his wife lived

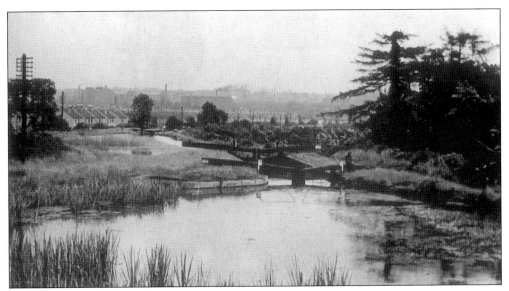

View of the canal from Woodyard Lane in 1946 with the 'staircase' of lock gates rising from Nottingham. The houses of Charlbury Road are on the left. (Miss Palmer)

here. 'The carriage had fireplaces at either end and also from end to end was fitted with red carpet. The table, chairs and basic furnishings were of the Victorian-Edwardian style but table lamps, lamp shades, ornaments, brass saucepans and horse brasses adorned every nook and cranny. The carriage was a lovely warm and cosy place but it needed to be because, as in all parts of Wollaton, fog shrouded the fields for days in midwinter and snowdrifts were commonplace around Christmas time. Percy and his wife used to get their supplies from Raynor's Farm, just over the bridge there, but if they needed to shop in town they usually took the path between the fields and through Balloon Wood and caught a bus to Ilkeston at the crossroads.'

Percy Ping reminded Loll of the cartoon character 'Popeye the Sailorman' because he was always busy checking the work gangs along the towpath 'and seldom did you see him without that beloved cherrywood pipe protruding from his lips.'

Trowell Road

The cottagers along Trowell Road occasion-ally called upon or summoned the local cobbler Jack Upton when they wanted their boots or shoes repairing. His cottage backed onto Davison's field and the canal and today is a private residence. Jack Upton cycled every other day from Wollaton Village to Balloon Wood crossroads collecting and delivering the footwear he repaired, and is remembered as both an astute raconteur and master craftsman.

Nearby in a cottage lived the Widdowson family of whom my friend (and relater of a proportion of the incidents mentioned in this book), Wilfred, was a hardworking son.

Old Lead Tail

In one of the Trowell Road cottages lived a dog that became a local legend. Cyril Allen and his friends used to call him 'Old Lead Tail' because most mornings when as young boys they delivered newspapers, they used to see him coming from the fields with either a rabbit or pheasant clamped between its jaws. The rangy mongrel's owner used to complain that his dog's hindquarters and tail were thickly peppered with the lead shot, fired from a gamekeeper's gun.

'In fact, as the dog became older so his tail became stiffer due to lead shot and if he had wanted the old dog couldn't have wagged his tail, that's for sure,' Cyril confirmed when we were sitting one afternoon around the hearth in Lodge Two.

The Firbeck Estate

According to a Trowell Road resident, most of the detached houses built either side of Trowell Road were erected around 1931-33. This included Park Crescent and adjacent roads to which the semicircular Firbeck Estate was added. Firbeck was originally a council estate without a nearby school, which fronted the relatively narrow paths that led off to Raynor's (Model) Farm, the adjacent canal and Balloon Wood. The housing estate was completed around 1949.

Wollaton Park Incident

In around 1948-49, Von Nida was playing an exhibition round on the golf course when a stag tangled its antlers in the peripheral ropes of a green. Still with the ropes attached the stag made for the lake, as all red deer make

Wilfred Widdowson tempting Tommy. (F.W. Parkes)

for water then they are under stress, and possibly due to the ropes becoming entangled in the waterweed, the stag was held beneath the surface and drowned before the deerkeeper and his team discovered its whereabouts.

Outlasting Their Time

When the Estates Department purchased a couple of Fordson tractors and trailers to ease the workload on Wollaton Park, the question arose as to whether or not it would be viable to retain the three remaining workhorses that had previously been used for hauling the timber wagons and flat drays. Kitty, a bay mare, was close to her time anyway and when she became listless a veterinary officer advised that she was near the end of her dotage. Thus it was decided that she should be quietly put down.

Her team mate, the black stallion Jasper, also came under veterinary scrutiny when he was gored in the neck and shoulders by a rutting stag. The workhorses in those days were grazed occasionally in Wenn's Paddock (now a plantation) which divided the Gorsebed Open Wood from Wellingtonia Plantation and so it was presumed that, in their search for acorns, a group of hinds leapt the fence and entered the paddock one night and the stag which followed regarded Jasper as a rival. Unfortunately, Jasper's wounds were deep and never healed. Consequently he too was put down.

The remaining horse was Tommy, a white stallion with a docked tail, whom I glimpsed grazing Middleton's Paddock one Sunday morning when my sister and her friend took me down to the grove where we gathered horse chestnuts. Had he approached, and being under school age, I would no doubt have found Tommy intimidating for, accord-

ing to Lionel Baker, when the white stallion began nuzzling anyone he was not averse to clipping the buttons off the front of their jacket one by one, and on more than one occasion Lionel had been present when Tommy thrust his muzzle hard into the small of someone's back thus causing them to fall flat on their face.

Tommy did, however, retain his human friends. Wilfred Widdowson was one and the postwoman who cycled up from the village was another. Whenever he caught sight of her, Tommy would gallop across Middleton's Paddock and stand at the low field gate in readiness for his sugar lumps. The gate opened inwards, yet Tommy surely acquired the habit of grasping one of the narrow cross supports between his teeth and, by moving backwards and sideways, pausing, then literally using his head to keep the gate open, he slid through.

Jesse Oliver readily assumed this on a Friday afternoon of thick fog when he was distributing fresh hay into the stable block stalls below the clock. Jesse paused when he heard the echoes made by a horse walking to the archway near the mounting blocks. Then to his surprise the rounded door handle turned, the door swung open and 'there stood Tommy. Come in early on a freezing afternoon,' smiled Wilfred Widdowson, who ended his story by reflecting on the fact that Tommy eventually collapsed and died one December day at the age of thirty-two and a half.

Leonard Wilde

The Natural History Museum's first taxidermist, Leonard Wilde played an important part in giving the museum an updated appearance. Particularly outstanding were his habitat backgrounds and environmentally related displays.

The Great Hall featured sloths, zebras, leopards and kangaroos alongside a splendid British Mammals wall display with each animal family, foxes, hares, otters, etc. featured in individual display cases. The Bird Room, housing exhibits donated from The Welbeck Collection, similarly revolved around dioramas with habitats painted in the background.

After the war a Freshwater Fish Room was opened, again displaying Leonard Wilde's superlative talent in positioning the exhibits according to their natural requirements. The two or three pike taken from the River Poulter in Clumber Park were particularly impressive.

The Cockburn Mammal Room displayed roe deer and a full-sized Wollaton Park stag. The shield-mounted heads of red deer stags and sambur deer were positioned along a south-facing wall. Various antelope, bison and water buffalo heads met the visitor's gaze as they entered the staircased entrance hall.

Leonard Wilde was originally employed as a propagation assistant in the kitchen gardens but quite obviously he was also a keen local naturalist with a sharp eye for detail and a constant awareness of the world around him. He was a self-taught taxidermist, having begun in the garden shed. Those few visitors who were allowed into his workshop noticed Leonard's habit of covering over with newspaper the animal or bird on which he was working before he turned to greet them.

Described as a shy, retiring type, Leonard is also remembered as a smoker whose hands trembled immediately he put down his scalpel and lit a cigarette, yet who had full control of the scalpel the moment he returned to it. In 1951-52 Leonard Wilde moved into one of the first houses to be built on Deepdale Drive.

CHAPTER 15
The Fifties

Traces of fog along Lime Avenue. (From the author's collection)

The Loss of a Lady

Sheila Russell died on 2 December 1951 at the age of sixty-five. The funeral service held at St Leonard's church was, according to Ida Hooley, packed to the hilt with mourning parishioners, friends and councillors. She was buried alongside her mother and father beneath the magnificent beech tree in Bramcote Lane Cemetery.

The Author's Recollections

This was the last decade in which Wollaton Park retained the atmosphere and sense of seclusion that its residents, workforce and visitors had experienced in the past. Early on midsummer Sunday mornings, couples from the Middleton Boulevard estates strolled beneath the lime trees from which foliage screened but unmistakably present cock blackbirds and chaffinches tuned. The couples enjoyed looking over the formal gardens and sitting

for an hour or so on a Camellia House seat enjoying the sunlight.

Golf was still not played on Sundays but golf course activities centred upon the red deer hinds which stilted across Arbour Hill to seek the shade of the copper beeches in Deerbarn Hollow, their calves trotting behind them like small replicas. Throughout the Sunday afternoons the families came. The Hall and the Natural History Museum opened at 2 p.m., although anyone under the age of eighteen was still not allowed in 'unless accompanied by an adult'.

Thompson's Wood was rigorously patrolled by gamekeeper Harold Walton and the lake path, his companion Charlie Todds. George Glanville, a tall retired police officer who lived on Orston Drive, patrolled Digby and Lime Avenues alternately and ensured that all dog owners walked with their pets on a lead.

Cars were allowed in by way of Lime Avenue, at the top of which the drivers were obliged to turn right and proceed along Albany Avenue before parking at the top of Digby Avenue at Wellingtonia Plantation. I remember George once commenting on how busy the park had been, and that no fewer than forty cars had been parked there at one time. Today that number could sometimes be increased to four or five hundred!

The Fifties

Meanwhile, behind the scenes, the War Department conferred with Nottingham Corporation Estates Committee with regard to the army and prisoner-of-war camp being retained, because certain War Department members considered the area 'an excellent training ground'. But in the autumn of 1952, the Department relinquished its hold on the

forty or so acres, and the estate workers were assigned to help dismantle the many Nissen huts and clear the boundaries of the high, unsightly and rusted barbed wire.

Park Superintendent Frederick Hallows joined in with his workers at most tasks, sometimes digging or assisting with gardening chores while still wearing a suit. Lionel Baker, back from wartime service, was soon promoted to gardener foreman, a position next in line to that of Wilfred Widdowson.

In the autumn and winters of the early to mid-fifties, there were relatively few visitors to the parklands, and those who came usually made straight for the Hall and courtyard cafeteria which was situated in the original indoor riding school. It was on Sundays in the winter that I used to go with my friend Max, despite fog swathing the lake hollows and the silence broken only occasionally by water dripping from the tree branches. Whether we had the leashed dogs with us or not, he and I always collected acorns as we made our way up Digby Avenue where still a few pheasants, rabbits and the occasional red squirrel could be glimpsed. Other than feed our acorns to the Estate Department's English and Wessex Saddleback pigs, our intention was always to learn something more about Wollaton from stockman Bill Pacey, last of the workforce's grey bearded sages.

Stooped and carrying the reputation for never once having removed the black beret from his head whether he was indoors or out, Bill mixed the pigswill twice daily and at around half past three on winter afternoons distributed beet and mangolds on the slope leading down to the works yard and filter beds for the stags which came down ahead of the hinds. The gateway, beneath a cluster of horse chestnut trees, is still used and situated beside the Lakeside Café. The works yard

and piggeries were doubly fenced and screened from public view by laurel thickets. But if, like Max and I, people appeared at the gate, the pigs would lumber over to have their backs scratched and sample the proffered acorns.

Trundling his barrow on which two canisters of swill was balanced, Bill always greeted us jauntily, and as he slopped the swill into the troughs, used to relate the latest occurrences in relation to being employed at Wollaton Park. Several times he explained his habit for sorting through the pigswill because when the Middletons were residing at Wollaton Hall careless maids and table helpers, no doubt, inadvertently scraped items of expensive cutlery into the waste bins, the contents of which were eventually taken down to the stockyards to become transformed as swill. Over the years Bill acquired so much cutlery that his wife bought a china cabinet in which to display it.

Moreover, Bill also acquired several plates, cups and saucers in this way!

What we youngsters also found fascinating about Bill was the way in which he occasionally spat neatly and sideways without once taking the pipe stem from between his teeth. My friend and I resolved that when we were grown men we would do the same.

On those and following Sunday afternoons, I used to bask in the fog-swathed silence while watching the stags, filing according to the herd pecking order, down to the gate besides which Bill had scattered their swedes and mangolds.

Recollections of the Fog

Fog in Wollaton was commonplace in those times, although the villagers, estate workers and colliers were aware that it was the proximity of the low lying Trent Valley and the

Fog also swathed the canal towpath. This long pound extended from the colliery almost to Coach Road but has since become Torville Drive. (From the author's collection)

lack of wind that caused it to linger, sometimes for three or four days. Then I would hear them repeating the local phrase: 'My God, they've been working overtime again at Beeston Fogworks!'

One Saturday evening I walked along Digby Avenue to meet and converse with patrolman George Glanville, who habitually wheeled his bicycle from the courtyards but free-wheeled down Digby unless he met someone he knew. As we walked, George and I, the only sound that we heard was the clashing of antlers as two stags tangled in mock combat. On another occasion when a pair of mature mute swans spent weeks aggressively chasing eight or nine young interloping swans from the lake, George told of how he had stood by the fishing hut with the lake blanketed by fog, then heard the surging of water and just glimpsed an arch winged swan cutting a path across the surface as, in ethereal effect, it pursued a younger bird. He also logged their movements by listening to the wing beats as the swans took off across the lake. The night fogs were of course the worst, and quite often my mother and I would walk from Chalfont Drive to Toston Drive to visit my auntie and uncle.

The Middleton Boulevard bungalows had each been fitted with an old-fashioned fireplace and cooking range which I found not only fascinating but comforting. Compared with the household standards and designs of modern times, this would be regarded as a cumbersome object, for the kitchen range was black enamelled and had to be cleaned and re-laid each morning. Besides an oven complete with stock pot and stew pot, kindling could be dried in the hearth, the coke or coal buckets placed alongside and woolly gloves, scarves and wet socks positioned on a rack while shoes were arranged along the fender.

Here beside the range my mother and auntie conversed while my uncle and I played dominoes, cribbage and table skittles. When the time came to leave, usually around half past nine, we often opened the back door and stepped into fog blankets the like of which I have never seen since. Sometimes my uncle would accompany us to the Crown Island where the bridge, by the thirties, had been widened and a sizeable traffic island positioned to maintain a flow of traffic between the five converging roads. On these nights of thick fog, I can vouch for the fact that the traffic was far from flowing. Quite often, and especially at the Crown Island, it was at a complete standstill, with the voices of car and bus drivers re-echoing through the fog as they queried their whereabouts or issued directions to the perplexed drivers in front or behind them.

Nor were matters eased on the night the red deer herd broke from the allotments on Sutton Passeys Crescent, trotted down Hawton Crescent and began quietly grazing the turf of Middleton Boulevard's central reservation. Several of the stationary motorists then explored the possibility of having somehow taken a wrong turn and believed themselves to have been on Lime Avenue in Wollaton Park.

When my sister and her husband moved into one of the first houses to be built on Deepdale Drive, my mother used to baby-sit while they went to a local cinema, quite often the Essoldo at Lenton Abbey. I would join my mother at Deepdale but only after I had walked through Wollaton Park or along the canal in the late afternoon/early evening. On the drive home in my brother-in-law's delightful Morgan sports car we again encountered fog so thick that by the time we reached Eton Grove, like the passengers of other cars I would have to get out and walk

in front of the bonnet until we were level with the Crown Hotel, when my brother-in-law was then able to follow the kerb along to Chalfont Drive. On several occasions my mother suggested he stayed the night but he always drove back, although one night it took him one and a half hours to return to Deepdale Drive.

Memorable Events

In October 1953 a military tattoo was staged in Wollaton Park with the Army, Royal Navy and Air Force all staging demonstrations, recruiting displays and events. The park was open until midnight on the Saturday, when the formal gardens were floodlit, with the holm-oaks and cedars of Lebanon providing settings for Walt Disney tableaux. On one occasion the beam of a searchlight trained on the lake located a swan pair and their brood of six well-grown

cygnets drifting by the wooded shoreline.

In July 1956, the Royal Agricultural Show was again staged at Wollaton Park with equestrian champion Pat Smythe competing in most of the classes devoted to her sport.

Building in Progress

When the houses of Deepdale Drive, the final stages of Arleston and Renfrew Drive were being built, Nottingham City Council in planning the first phase of Wollaton Vale built 140 houses and bungalows along the internal roads. Consequently, couples and families moved in between 1952 and 1954 and thus reduced the council house waiting list. Originally to be called the Model Farm Estate, the estate was eventually given the name of Fernwood.

The 140 acre tract of fields between the Vale and Deepdale Road still attracted much wildlife and I recall a pair of barn owls hunt-

This stretch of the canal adjacent to Radford Bridge Road and Charlbury Road was drained in 1955 and has since become the Seaford Avenue recreation ground. (From the author's collection)

ing for their fledged brood along the derelict hedgerows one midsummer evening. The owlets were positioned singularly in the great oak and ash trees. One, trying out its wings, settled on my sister's garage roof at Deepdale. This tract of land was built on soon after that summer and is now the green and pleasant complex of the Fernwood School. Building was also underway along Russell Avenue and, much to my youthful dismay, by 1952-53 houses backed onto Harrison's Plantation. The corner plot adjacent to Martin's Pond was also bought by a firm of local builders and houses were built accordingly.

Park Superintendent Changes

Towards the end of the fifties, the Park Superintendent, Frederick Hallows, died while crossing Piccadilly Circus, London. His position was filled by Lionel Baker who remained as Park Superintendent until his retirement around 1978-79.

Fox Intervention

Throughout these years, the Wollaton Park woodlands still maintained a few groups of pheasants; usually Arbour Woods, Thompson's Wood and The Gorsebed served as a substantial habitat for these splendid birds. At dusk George Glanville and I would watch them crossing Digby Avenue. The dominant cock bird, who ran 'cock-cocking' across our path, we christened 'Old Longspur'. Partridge 'coveys' continued to visit, particularly in the autumn, and woodcock wintered in the woods then just as they do today.

A dog fox seen crossing Pilkington's Paddock in the winter of 1954 caused some consternation, but even more so the dog fox, vixen and cubs that gamekeeper Harold Walton located in Deerbarn Wood the following summer.

A family or two of stoats were occasionally glimpsed in the glades and weasels tenanted the formal gardens and adjacent Ice House Plantation. One weasel entered the Camellia House and commenced hunting when patrolmen Ted Hardy and I were quietly conversing.

Wollaton's last known red squirrel was found dead in 1955 by a golfer crossing Deerbarn Hollow. The grey squirrels were by then becoming surprisingly well-established.

CHAPTER 16
The Sixties

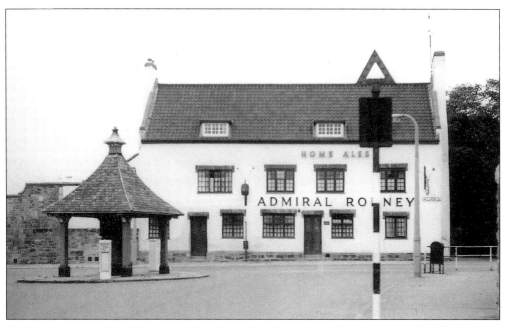

Wollaton Square with traffic signs and modern sodium lamp posts. (From the author's collection)

Following the death of her sister, Marjorie Russell continued to visit and serve on the committees of the several community centres established throughout the area. She was also a central figure of the Ladies' Circle, which met at the Manor Farm Centre in Bilborough, until she died on 11 May 1960. She was buried in the family plot at Bramcote Lane Cemetery.

A noticeable change occurred in the village when the library was built and opened by the Lord Mayor, Alderman Llewellyn Davies, on 29 June 1961. The frontage of the Admiral Rodney was also refurbished and splendid; the pub appeared on the postcards sold at the post office around that time. Inevitably changes occurred in Wollaton Park when the Estates Department was dissolved, and all the Nottingham parks were administered by the Nottingham Parks and Recreation Department which was centred at Woodthorpe Grange, off Mansfield Road.

Among the plans to make most parts of Wollaton Park accessible to the growing

Lime Avenue was opened to through traffic as an experiment that fortunately failed within two years due to motorists consistently exceeding the speed limit. (From the author's collection)

number of visitors and daily walking public was that of creating an entrance at Parkside, thus for the first time in the park's long history allowing the public to walk down Thompson's Field to the inlet at the north arm of the lake. As expected, this entrance was used each morning by a retinue of local dog owners who crossed Thompson's Field grazed by store cattle. Together they wrote requesting a laid path instead of a field path. Their request was granted. The second letter complained that the path became bespattered by cow manure. That said, a fence was erected keeping the cattle to one side of the field. The third letter was from a group who habitually wore wellingtons and walking boots. They wanted to walk over the field. To meet *this* request a stile was put in. Then a disabled person wrote saying that he or she couldn't get over the stile and so a gate was installed.

Had I been the Park Superintendent I would not have given way to the next request which was to open up the Duckride so that the early morning dog walkers could gain access to all four sides of the lake instead of having to walk the moat bank. The results of that decision can be seen when one studies the once beautifully turfed Duckride in present times. When this intended 'blind bank' was opened up, the wintering wildfowl also ceased to gather in the numbers which were known in the past. Then a woman released six home-reared hybrid ducks onto the lake, the descendants of which are still there.

Slowly the lake was losing its atmosphere to people who claimed that because they paid what were then called general rates, they wanted their 'home park' tailored to their requirements. All the fields and paddocks were opened up, but because the deer needed forage and occasional sanctuary, the woods

120

remained closed. The public were also allowed into the Gorsebed Open Wood and Goode's Field was leased to the Sports and Education Committee which laid out the football and rugby pitches.

Wollaton Park was now fast becoming a municipal park, sadly and blindly at a time when country parks were first becoming established. Dog owners were then allowed to have their charges off a lead and before the sixties were out, the fence of the Middleton's and Pilkington's Paddocks were taken back, thus reducing the paddock size but with the extra ground to be used as car parks.

Finally, the uniformed police patrolman was replaced by a man in a peaked cap wearing the Parks Department's uniform. There were four such patrolmen: George Smalley, whose beat was the formal gardens; George Barker, the last resident of Beeston Lodge; and Albert Brittle and Cliff

The Duckride between Wollaton Park lake and moat was opened to the public in the sixties and the lake bed tilted due to colliery subsidence. (From the author's collection)

Wollaton Park's largest stag since 1940, assessed by both antler span and body size, is seen here with fallow deer on Middleton's Paddock in the winter of 1964. (From the author's collection)

The canal and Colliery Row from the now non-existent canal bridge. Today we know this tract of land and water as Torville Drive. (From the author's collection)

Hurt, who divided the main park acres between them.

Beyond the park the houses and roads adjacent to Woodbank Drive were built, and Wollaton Vale with many of its roads bearing the names of Lake District locations becoming established. Grass verges, planted with cherry, crab apple, hawthorn and horse-chestnut trees, enhanced the scene and the Fernwood estate roads gradually converged with both Bramcote Lane and Wollaton Vale.

The Wollaton canal was also drained, the lock gates desecrated or covered in by top-soil, and over a period of Sundays the accommodation bridges were brought down 'by dynamite', according to one of the gangers. The humpback bridge on the main road between Glover Avenue and Colliery Row was gradually sheared off and again top-soil was used to raise the road and pavement.

A co-ownership scheme comprising of a first phase of 174 houses and bungalows then a further 59 became operational in the late sixties, with many of the gardens being built on the original canal bed. Named Moorsholm Drive, this site was officially opened by the Lord Mayor of Nottingham on 25 September 1969.

A pub was built and opened on the corner of Colliery Row where in 1792 the King's Head had stood. This new establishment was called the Deep Cellar but has in recent years been renamed the Roebuck.

Yalding Drive and the adjacent gardens were in a later building phase continued from Moorsholm, and eventually joined with Wollaton Vale.

CHAPTER 17
Recent Times

Torville Drive. When the colliery was demolished the houses remained, as did the horse chestnut tree which once stood at the colliery entrance. (From the author's collection)

The many changes that have occurred in Wollaton between the 1970s and today would fill another volume. In a book of this size, it is difficult to choose between what to put in or leave out. Therefore the following paragraphs relate briefly to the changes that I personally consider significant in relation to allocated space and Wollaton's extensive social and overall history.

For instance, I was delighted to learn that way back in the '50s and '60s children still chose the environmental path to school and I have at least two accounts of schoolchildren leaving the Fernwood estate and walking along the canal towpath, and others slipping into Harrison's Plantation via the back garden fence and again connecting with the canal after walking Coach Road or the sad remains of Woodyard Lane.

Leading off from Torville Drive is Barnum Close and Dean Close, built on the colliery site and close to the Trowell Road Co-operative Superstore. (From the author's collection)

Mrs Jackson and her family on the old Middleton Brickyard site where for some years the Jacksons maintained a smallholding. (S. Jackson)

Fylingdale Walk, fringing the North British Housing Association site built on the old Middleton Brickyards, with Grangewood Road following the original canal route to the right. (From the author's collection)

Significant for many Wollaton and Bilborough residents was the opening of the Greater Nottingham Co-operative Society superstore on Trowell Road, which was originally called Main Stop. It was erected in 1977, on the ten-acre site that had once served as the colliery sports ground. The only point I personally found unsettling about this opening was the prospect of a car park estimated to hold 705 vehicles!

From the 1970s the allotment holders adjacent to Martin's Pond quite rightly formed an alliance to prevent the building firms taking over, and although offers have allegedly been made, they remain steadfast to their cause. As for Martin's Pond itself, work managed by the Nottinghamshire Wildlife Trust in the 1970s resulted in a periphery channel and inner reed bed wildlife habitat, which has proven suc-

cessful to the point of attracting such wintering visitors as water rails, the various flocking species that roost in reed beds, and the occasional kingfisher similarly attracted to the rejuvenated streams now surging between the banks of Harrison's Plantation. Insects, trees and flowers have also benefited through the efforts of the Martin's Pond conservation teams. But sadly the local vandals continue to delight in filling the broad walk pools with cartons and drink cans. And the fact remains that each future generation will continue to do so.

By the early seventies the Bramcote Lane shops, Hemlock Stone public house and the nearby Health Centre were operational, with Thoresby Road rising to the summit of Bramcote Hills and allowing access to Derby Road.

In 1973 the North British Housing Association purchased the old Middleton Brickyard site where 360 two and three-storey blocks of flats, houses and bungalows were erected. At that time this was considered 'the longest housing association scheme undertaken in the East Midlands' and the cost was in excess of £3 million. Fortunately, the old name of Grangewood was retained and the private block of flats known as Grangewood Court was built on the original site of Raynor's Farm. Close to the subway, bordering a private garden, a section of the old canal towpath hedgerow is still discernible and the comparatively new Canal

Wollaton Park's mature woodlands are closed to the public and serve as wildlife reserves. In the past thirty years many American (red) oaks have been introduced. (From the author's collection)

Trail guides newcomers from Latimer Drive along the old towpath to Langley Mill if they feel the need for a good historical and interesting walk.

Fresh Bloodstock

The Russell sisters, had they still been with us, would have been delighted by the Nottingham Parks Committee's decision to purchase two red deer stags from the Charles Lucas Herd at Wareham Court, Sussex, in order to regenerate the herd. The number of red deer had been reduced to its all time low, twenty-two, but with the arrival of the new stags it was decided to rebuild the herd and allow at least eighty head to roam the parklands again. A year or so later Lionel Baker visited me, seeking advice on where to obtain two first-rate bloodstock fallow bucks. Woburn Abbey was my first choice, and two bucks were duly released into Wollaton Park within weeks of Lionel's enquiry. One unfortunately was fatally gored by the existing bucks but the second established a pecking order position within the herd and bred for three or four seasons.

In Wollaton Park, before he retired, the late Harold Walton, under Lionel Baker's supervision, created plantations of trees that could be used in the future to replace the ageing giants that would one day need to come down, if indeed they were not felled by the winter gales. Gaps were already visible among the limes of Lime Avenue, some of which had to be felled or severely lopped during the early '80s. In 1988 over 100 trees were planted on the Wollaton Park golf course.

As regards wildlife species, when the last pheasant and rabbit faded from the scene gamekeeper Harold Walton accepted the fact that foxes, disturbed by the local dese-

Farndon Green post office, built around 1927-28, still retains much of its original atmosphere. (From the author's collection)

cration of habitat, were breeding in the woods and coverts. Harold also quietly sanctioned my idea to introduce four badgers into Wollaton Park, one pair of which produced cubs the summer following their introduction.

In 1988 a new strain of white park cattle was introduced to Wollaton's still extensive paddocks.

Conservation and Hard Work

Mention should be made of the Wollaton Hall and Park Conservation Society's stalwart efforts in interpreting Wollaton's past and keeping a weather eye on the present, and here I am thinking in particular of 1983 when the society fought to prevent the

Wollaton Park barn from becoming a bar and restaurant. As regards the relatively new Rectory development, Mr Radford, who tenanted the Rectory in the '60s and '70s, owned a documented agreement stating that as long as the grounds maintained livestock the tenant could retain the high periphery fencing and so, in their turn, Mr Radford bred pheasants and later grazed a small flock of sheep on the site that had provided grazing for livestock since medieval times.

Swinging back in the direction of the city boundary at the Balloon Wood crossroads, I do not intend to bypass the Wollaton Vale Community Centre which began as an improvised hut-cum-office building adjacent to the Balloon Wood flats that were first occupied in the early '70s. One local pioneer was, I recall, Jean Smith. Since then, through

The open-plan design of Yalding Gardens adjacent to Wollaton Vale. (From the author's collection)

the admirable efforts of the Working Committee, the centre has developed considerably, a fact marked by the opening in June 1990 of the extension which was again made possible by the Working Committee's successful efforts to raise the required £35,000. May they go from strength to strength.

I have also to admit that, while I winced when I realized that developments like the appropriately named Deerpark and Smithson Avenue were being built adjacent to Bramcote Lane, I do now think that they blend splendidly with the surroundings.

The peace once retained in and about Wollaton Square has now regrettably been shattered by the rise in motor vehicles. 'Progress,' some may echo, but the motorist misses so much. For instance, I like nothing more on a winter's daybreak than to be seated on a double-decker bus coasting down Church Hill and glimpsing Wollaton Hall silhouetted against the vivid red sunrise with the windows framed from one side of the building to the other due to the combination of the Hall's position and the play of light.

As for Billy Archer and all the bygone keepers who led a ceaseless campaign against the once numerous rabbit – recently, and out of curiosity, I joined a group of twenty people on Middleton's Paddock staring enraptured at the pet rabbit nibbling the turf alongside the boy who had secured it gently to a lead and collar. Surely that tells us something about the times in which we are living?